IMAGES
of America
BONITA SPRINGS

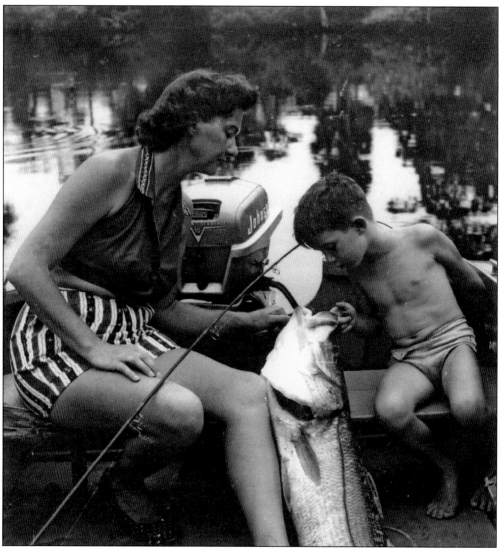

This photograph, taken around 1955, shows Ellen Gourley and her son Dan. At the time, Ellen and her husband, Wendell, owned the Imperial River Tourist Court. The large snook is a good representation of the Bonita Springs slogan, "Home of the Tiger Snook." Dan Gourley went on to join the volunteer fire department when he was 16. He eventually became the community's fire chief and retired in 2006.

ON THE COVER: The 1941 cover photograph shows five young people standing by a chickee hut near what is believed to be the intersection of the Broadway and Hogue channels in the background. The group includes, from left to right, Geraldine Humphries Strickland, Vance Strickland, Helen Hayes Galloway, Armond Humphries, and Louise Humphries—all longtime residents of Bonita Springs. The chickee hut is a common sight in Southwest Florida and is emblematic of life in the region.

IMAGES *of America*
BONITA SPRINGS

Chris Wadsworth, Allison Fortuna, and
the Bonita Springs Historical Society

Copyright © 2008 by Chris Wadsworth, Allison Fortuna, and the Bonita Springs Historical Society
ISBN 978-0-7385-6721-1

Published by Arcadia Publishing
Charleston, South Carolina

Printed in the United States of America

Library of Congress Catalog Card Number: 2008934424

For all general information contact Arcadia Publishing at:
Telephone 843-853-2070
Fax 843-853-0044
E-mail sales@arcadiapublishing.com
For customer service and orders:
Toll-Free 1-888-313-2665

Visit us on the Internet at www.arcadiapublishing.com

*Chris: Thanks to my wonderful family—
wife, Mari, and sons Ryan, Adam, and Sean.*

*Allison: Thanks to my mother and father who taught me a love of
the English language, Kyle and Jillian, and my supportive friends.*

Contents

Acknowledgments		6
Introduction		7
1.	Land of Promise for the Settler	9
2.	The Wild, Wild Southwest	23
3.	Under the Banyan Tree	35
4.	Gateway to the Gulf	53
5.	Timber to Cut, Groves to Grow	63
6.	"You Can Pitch a Tent Here"	73
7.	Gators and Panthers and Bears! Oh My!	89
8.	Remember the Dome	101
9.	Donna's Fury	111
10.	From Humble Beginnings to Boomtown	121

ACKNOWLEDGMENTS

Thank you to Luke Cunningham, our editor at Arcadia Publishing, who jovially guided us through the book process.

Thank you to Charlie Strader for his early interest in this project and his passion for history. Thank you to Byron Liles, Jean Hogue, Don Trew, Dan Gourley, Virginia Schirrmacher Beville, Ronald Lyles, Robin and James Weeks, Ronda and Terry Lawhon, Carmen Reahard, and Anna Mackereth for sharing their stories, photographs, and many memories.

Thank you to Charles LeBuff, a former guide at the Everglades Wonder Gardens, for his delightful tales of adventures at the popular attraction.

Thank you also to Ed Schaefer, Suzy Valentine, Patricia Valentine Whitacre, Rebecca Jones and the Edison Ford Winter Estates, Shelly Redovan and the Lee County Mosquito Control District, Matt Johnson and the Southwest Florida Museum of History, Terry Brennen and WGCU Public Media, Larry Baldwin and the Naples–Fort Myers Greyhound Track, and Dennis Feltgen and the National Oceanic and Atmospheric Administration (NOAA).

Finally, a special thank-you to E. P. Nutting and Mildred Briggs—gone, but not forgotten. Their earlier works on Bonita history proved invaluable in the writing of this book.

The majority of photographs presented in this book come from the archives of the Bonita Springs Historical Society, unless otherwise specified. Many additional photographs were shared by local residents and families. Several new photographs were supplied by nonprofit organizations, area businesses, or government agencies and departments.

INTRODUCTION

A good snapshot stops a moment from running away.

—Eudora Welty

Any true history of Bonita Springs does not just date to the late 1800s. Rather, one must look farther back to the Native Americans that inhabited this land for thousands of years before the first white settlers.

Research has shown evidence of man along Bonita's stretch of the Gulf Coast for some 8,000 years. Their massive shell-filled mounds were a common sight into the 1900s.

In more recent centuries, the Calusa Indians had villages with a population in the thousands in and around what is today Bonita Springs. However, the arrival of Spanish explorers marked the beginning of the end of the Calusa's reign, and they were mostly gone by the 1700s due to disease, warfare, and slave trading.

U.S. Army surveyors first explored the region where Bonita Springs lies during the Third Seminole War in the 1850s. Another group of surveyors came through the area in the 1870s. They made rough maps of the region and moved on.

In the late 1880s, a new settlement arose, nestled in the woods of what was then the middle of Lee County. This community, initially called Survey after the surveyors who had earlier camped here, was centered around a tropical fruit plantation. It would one day become Bonita Springs.

Despite the plantation's failure due to an ill-timed freeze, folks found the tropical beauty and serene wilderness along Surveyors Creek to be a perfect antidote to the more metropolitan communities elsewhere.

Bonita Springs sat back, sleepily, and years slipped by.

For decades—well into the 20th century—Bonita Springs remained a place set apart from the wider world. To the north, Fort Myers grew and urbanized as the county seat and as a business center. To the south, Naples had already established its reputation as a getaway for the well-heeled. Meanwhile, Bonita Springs was for many just a spot to hunt and fish, or to stop and get an ice-cold soda on the way to Tampa or Miami.

For the most part, Bonita Beach, a beautiful, pristine stretch of sand, islands, and mangroves stretching for miles, was the home of only the hardiest of souls and a few hardened old sea salts. Bonita families went there on weekends, but the trek over sandy paths was often difficult.

Development was slow and steady in Bonita's early years. Sure, new roads and neighborhoods were laid out and a small business district took shape, but it was hardly a boom.

The biggest population jumps happened each winter, when weather-weary Northerners flocked to Bonita's warm, sunny clime to fish, hunt, and swim. They came by the hundreds, many towing shiny, silver campers called "tin cans" by the locals.

Most of the excitement for visitors was found along the stretch of road originally called Heitman Avenue. It later became part of U.S. Highway 41 and part of the Tamiami Trail from Tampa to Miami. It is now called Old 41, and this is the name used throughout this book.

The increasing number of automobiles passing through town offered locals a steady clientele. Gift and souvenir shops, lunch stands, and, soon, roadside attractions began to proliferate.

The original Shell Factory, the Everglades Wonder Gardens, and the Dome restaurant soon became landmarks that lured traveling families with big, bright signs and ready-made memories to take home.

Bonita Springs saw its share of action during World War II as servicemen from area training bases came for a little rest and relaxation. In the postwar years, many of these same servicemen returned, and little Bonita Springs grew again.

No history of the community would be complete without touching on the dramatic and deadly impact of Hurricane Donna in 1960. This ferocious storm devastated the village of Bonita Springs and the growing Bonita Beach area. Rebuilding would take years, but the influx of money and workers gave the town another boost going into the turbulent 1960s.

In more recent years, that growth has only picked up steam. The development of the new Tamiami Trail, the arrival of chains and big box stores, the millionaires who scooped up beachfront parcels and built their mansions—all helped change the face of Bonita Springs in the waning years of the 20th century.

Still, signs of what once was are still visible. Old 41 is still home to buildings and landmarks that have endured there close to a hundred years. The streets laid out by Bonita's earliest developers are still there—home to a multiethnic potpourri of old Bonita families and new arrivals.

The book you hold in your hands follows this basic outline of Bonita Springs's history—from the first permanent settlement in the 1880s to the boom years of the 1970s and 1980s. Far from an exhaustive, scholarly work, Images of America: *Bonita Springs* is more a family album of snapshots—people and places, milestones and memories, lives and legacies—all moments to be kept from running away, to be held dear.

One
LAND OF PROMISE FOR THE SETTLER

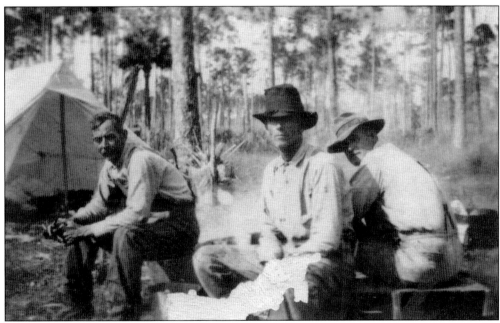

The earliest travelers and settlers in the Bonita Springs region found a wild, untamed land full of natural beauty and opportunity. Survey was the initial name of the community, named after the U.S. Army surveyors who spent time here while mapping the region. It was not until around 1912 that land developers renamed the community Bonita Springs and promoted Surveyors Creek to the Imperial River.

Bonita Springs is named for the natural spring that flows in the heart of the town. Originally just a bubbling mud puddle, the water would flow across the land into nearby Oak Creek. Later a small hexagonal enclosure was built around the spring, which continues to bubble today on the property of the Shangri-La Resort.

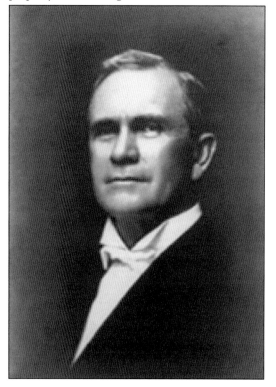

Plantation owner Braxton Bragg Comer came to Survey from Alabama in the late 1880s. With some 50 black workers, he started a tropical fruit farm near Surveyors and Oak Creeks. His bananas, coconuts, and pineapples were taken by boat to the nearest railroad depot in Punta Gorda for shipment to northern markets. When a severe frost hit during the winter of 1893 to 1894, Comer sold his 6,000 acres and returned to Alabama. Comer later became governor of Alabama.

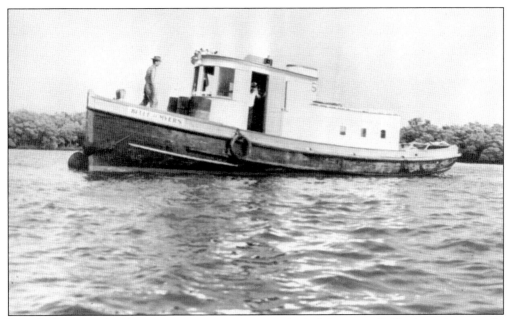

In early days, travel and transportation was almost exclusively by water. Sailboats and eventually motorboats, such as the *Belle Myers*, plied the Gulf waters, bringing passengers and cargo to Fort Myers, Survey, and Naples. When these vessels came up the shallow Imperial River, the crews would often have to arrive at high tide and use poles to push themselves when they got stuck on the sandy bottom.

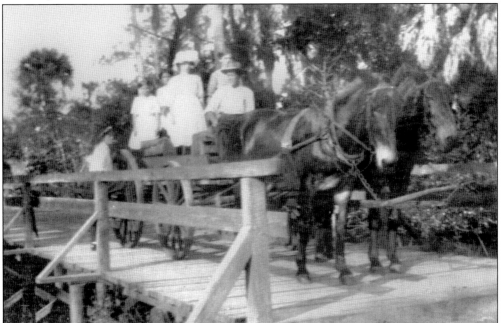

In the early days of Survey, sandy shell trails led through the woods north to Fort Myers. These were fine for horses, such as the team driven by Jim Harper in this 1914 photograph. However, the trails were not accessible to the new automobiles that were appearing in Southwest Florida. It was not until 1917 that the first passable road north to Fort Myers was built.

When roads became more reliable, Fort Myers businessman Harvie Heitman ran a hack service, or taxi, between Fort Myers and Bonita Springs. His cabs were famous for breaking down on the rough roads. Heitman and his brother, Gilmer, opened one of Bonita's first hotels in 1924. Harvie Heitman was developing nearby residential properties, and the 25-room hotel provided buyers from the north a place to stay while their homes were constructed.

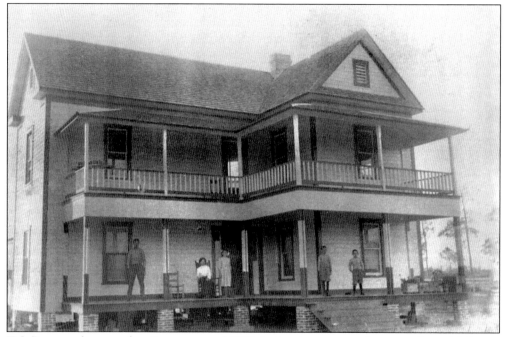

T. J. Barnes, who moved to Survey around 1900, built a large, roomy house on Imperial Street. Since there was no hotel at the time, the Barnes family would often take in boarders. T. J. Barnes's wife, Minnie, was well known for her hominy, which she gave freely to her neighbors. In the late 1920s, the Barnes family returned from a county fair to find that fire had destroyed their home.

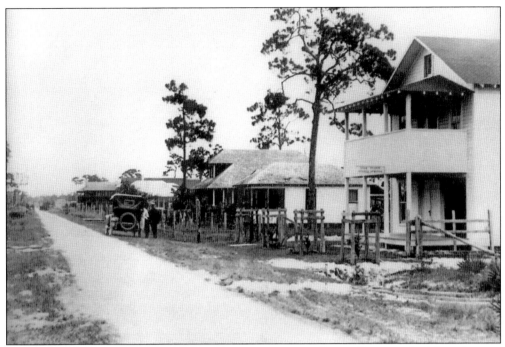

This early photograph looks north along Heitman Avenue in Bonita Springs, which later became the original U.S. 41 and part of the Tamiami Trail. Today locals know it as Old 41. From its early days, this thoroughfare was the main business corridor for the burgeoning community. The building in the foreground is the Illinois Apartments, which housed the post office on the first floor.

Native American shell mounds were once common around Bonita Springs. Many locals enjoyed pot hunting, digging through the mounds searching for Native American artifacts. Unfortunately, road builders who used the crushed shell as fill destroyed most of the mounds in the early 20th century. The original road to Bonita Beach, as well as many of the streets around what is referred to as "Old Bonita," was built on a base made up of shell mound material.

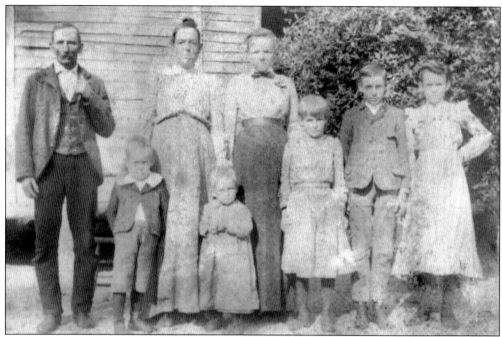

In 1897, Forrest Walker (second from the left) became the first baby born in Survey. When his parents settled in the area, they had to scrape together $40 for their 40-acre homestead. At the age of 20, Walker married 14-year-old Adnie, and they raised two boys and two girls. Walker worked as a commercial fisherman, a hunting guide, and a caretaker. He also built roads for Lee County. His pay was $1.15 a day plus some beans.

A common style of home in early Bonita history was the cracker house. Originally made of rough pine logs with sand floors, they were eventually made with milled wooden boards. A typical cracker house included shady porches for staying cool in these days of no air-conditioning. The homes were often elevated a few feet to allow cooling breezes to flow underneath. Angled roofs kept rain from pooling atop the home.

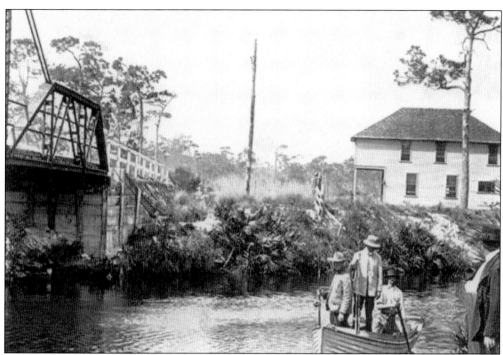

The first bridge across Surveyors Creek was made of planks and timber logs. It was built high enough that boats could pass under it as they moved up the river. The old wooden structure was replaced by a steel bridge (seen above) in 1907. This span served the growing community until the current concrete bridge was built in the late 1930s.

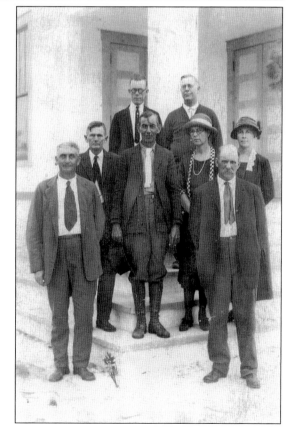

This classic 1921 photograph shows eight important members of early Bonita Springs society, including prominent citrus grove owners T. J. Barnes, J. Quinn, and Keitte Leitner. It also features George Glazer, an early reverend at the town's Methodist church. Pictured from left to right are (first row) Barnes and Quinn; (second row) A. M. Smith, Leitner, Bertie Sumner, and Jessie Fleming; (third row) Glazer and David Sumner.

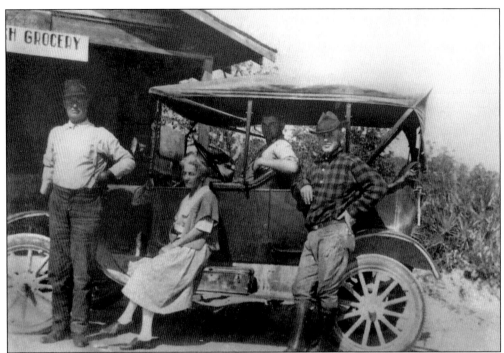

Built in 1926, Goodbread Grocery was a market and filling station operated by the Goodbread family. The tall man in the photograph is William Goodbread, and his wife, Josephine, is the woman sitting on the automobile's running board. For years, the building had a patio on the roof where travelers could relax and enjoy a meal. Like other buildings in town, Goodbread Grocery was designed in the mission style.

Goodbread Grocery had many owners and many names over the years. Longtime resident Don Trew remembers a time when the building was empty and children played marbles on the front porch. They climbed on the roof to pick mangos from trees and had to take care to avoid falling through the weakened roof. Today the overhang, pillars, and rooftop dining are gone, but the base structure still stands, operating as the Dixie Moon Café.

Boats would bring citrus from the fields out to the Gulf of Mexico to be transported to northern customers. The citrus boats would line up along the Imperial River, waiting their turn to load. One time a boat caught fire, and men nearby quickly cut it loose. It drifted across the river and burned. It was later discovered that the boat's owner had built a still on board to make moonshine.

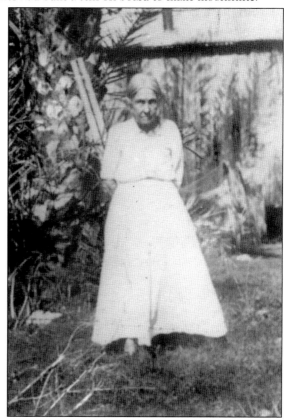

Mollie "Grandma" Johnson lived with her family on Mound Key. When doctors were scarce, this half-Cherokee woman acted as a midwife, tending to ailments using her own medicinal cures. She was protective of the Indian mounds on which she lived. During the hurricane of 1921, her property was the only land on Mound Key above water. She is buried in a tiny cemetery on Spring Creek Road.

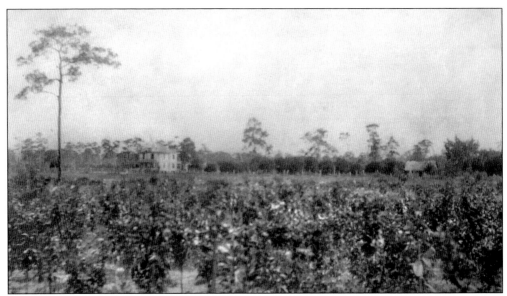

Keitte Leitner married Ada Bedell of Estero, and they moved to Bonita Springs, where they purchased orange and grapefruit groves, seen above. Leitner, a leading businessman, also operated a local freight boat. The couple purchased an Aladdin Readi-cut Home that was brought by boat and assembled at its present location on East Terry Street. It is visible in the distance in this 1914 photograph.

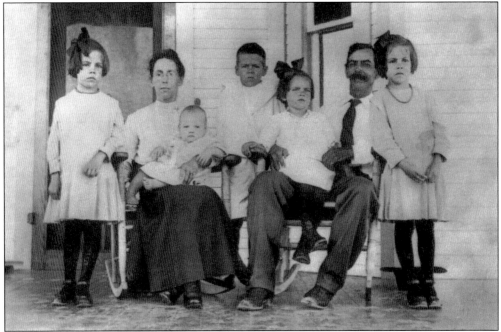

When Bonita Springs was first incorporated in the 1920s, Keitte Leitner served as mayor. The town later unincorporated due to financial troubles. The Leitners had five children. Twins Mary (far left) and Sarah (far right) both became schoolteachers who worked in Collier and Lee Counties for many years. In between the twins are (from left to right) Ada, Doris, Lewis, Alice, and Keitte Leitner.

Cordell Smith was a beloved citizen of Bonita Springs throughout his life. He was well-read and had an incredible memory. Smith contributed years of labor to the development of the town, including volunteering to deliver mail on foot to many remote areas in Bonita Springs. Smith, who lived in a bungalow on Old 41, was often seen walking around town, typically dressed in overalls.

Cordell Smith planted the banyan tree on the property next to the community pavilion seen on the far left in this 1921 photograph. He probably never would have guessed that it would grow into the giant, beloved shade tree it is today. A favorite climbing site for generations of children, the tree has long served as a town gathering place. It is a well-known Bonita landmark to this day.

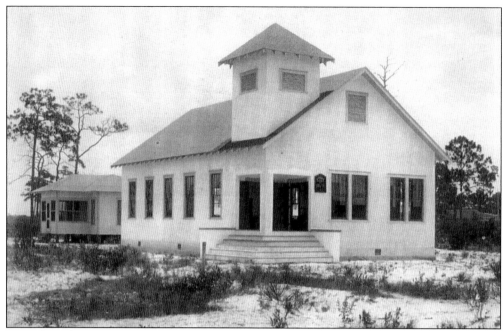

As early as the 1880s, preachers came by boat and horse from surrounding communities to hold religious services in Survey. The first church built here was the Lee Memorial Methodist Church, which was named not for Lee County but for a family that brought the building from Fort Myers. The wooden structure was completed in the early 1920s and cost $5,500. It is still in use today as the First United Methodist Church.

The second church built in Bonita Springs was a Baptist church. The first one went up in the Rosemary Park neighborhood in the northern part of the town. It ultimately burned down, and for many years, the Baptist congregation met in the community's pavilion by the famous banyan tree. The new Southern Baptist Church (pictured here) opened in 1939. It is still in use.

This is a 1910 photograph of the Survey school, which was actually the second school in the community. The first school in the area was a log cabin with a dirt floor and thatched roof. Early settler T. J. Barnes, a father with children attending the school, acquired desks, a blackboard, and a stovepipe from Fort Myers. The newer building was built near the town cemetery on land donated by the Walker family.

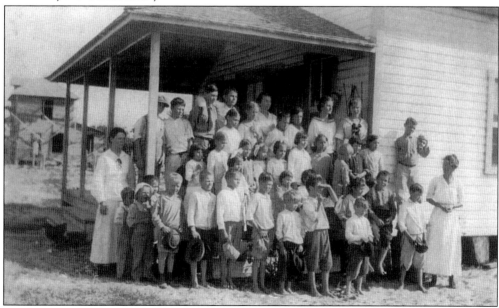

The first teacher in the new school was Alice Baldwin. By 1912, 70 students were enrolled. There was no lunch program in the early days, and students were often fed a bowl of soup and a glass of milk prepared by area mothers. Reflecting the subtropical climate of Southwest Florida, many children attended school barefoot. This photograph dates from 1915.

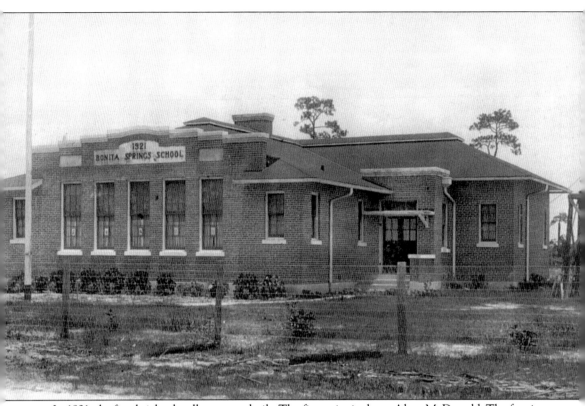

In 1921, the first brick schoolhouse was built. The first principal was Alma McDonald. The fencing in this photograph was necessary to keep out the cattle that roamed freely in the area. Before his death, longtime resident Glenn Liles told an area newspaper that the new school was the first place he ever saw a flush toilet. Initially, the school had no electricity. Schoolchildren from around the area set their daily schedule to the ringing of the school's bell, which stood outside the main entrance. The McCormick's dairy in Bonita furnished the schoolchildren with fresh milk. In 1927, the school expanded with the addition of a two-story building and an auditorium. The separate structures were united in the early 1940s, and a cafeteria was built in 1954. As of this writing nearly 90 years later, the building is still in operation as an elementary school for Bonita Springs. It is on the National Register of Historic Places.

Two

THE WILD, WILD SOUTHWEST

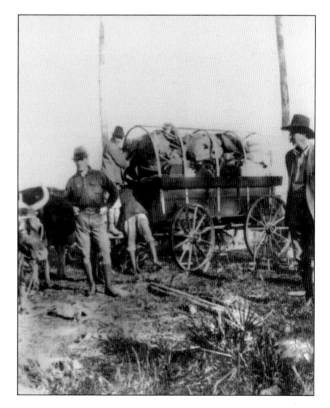

Since the earliest days of Bonita Springs, hunting and fishing have provided food for area residents and have drawn visitors from far away. Jehu Whidden, on the right, is seen in this c. 1900 photograph. The man facing the camera is believed to be Sampson Brown, who helped settle the nearby town of Immokalee. The group, with the wagon loaded and oxen team ready, is off to hunt the region's plentiful game. In those days, when you passed east of Imperial Street, you were in the wilds.

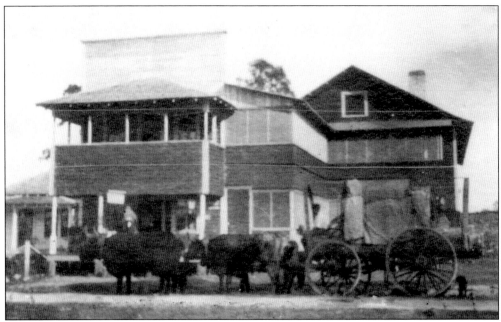

Bertie Storter was one of Bonita's earliest schoolteachers. She married Lee County school superintendent David Sumner. Together they purchased the servant's quarters of the Royal Palm Hotel in Fort Myers, which was scheduled for demolition. The building was brought in pieces to Bonita Springs by boat. Rebuilt, it was called the Bonita Hotel. Author Zane Grey reportedly wrote one of his books while staying at the hotel.

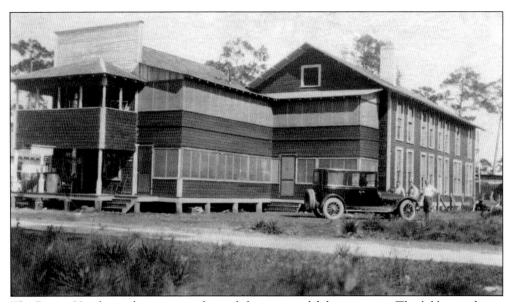

The Bonita Hotel soon became popular with hunting and fishing parties. The lobby was home to Bonita's post office for a time, and the public dining room became a popular meeting place. It was later called the Wayside Inn, a name everyone knew it by for years. In 2005, it was demolished after standing for nearly 90 years on the corner of Ragsdale Street and Old 41.

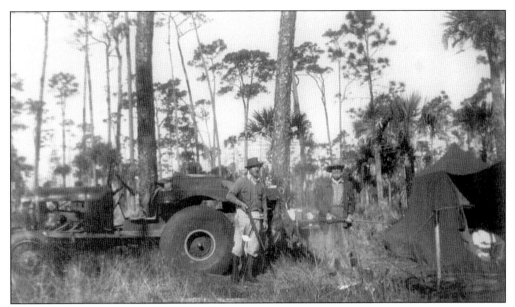

According to Glenda Johnson Smity, daughter of Verlie McMillan and Ray Johnson, this picture was taken at a hunting camp called Cabbage Island. The camp was located about six miles east of Bonita Springs. The men were hunting wild turkey and deer. Eastern Bonita remained a wild and remote place up until the 1980s, when Interstate 75 was completed and development began.

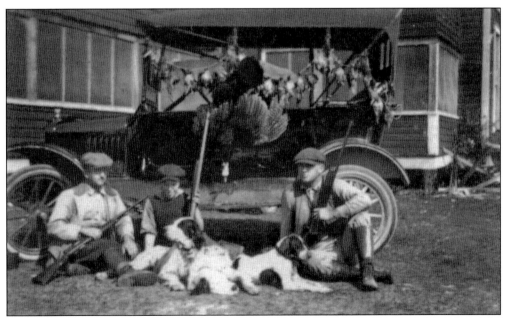

Hunting parties often came down from Fort Myers to enjoy the more remote wilderness of the Bonita area. Visitors from other states—especially the Midwest—were also commonplace in the early days of Bonita Springs, just as they are today. Many came looking for hunting trophies to take home. The area's abundant animals and often exotic game were perfect for them.

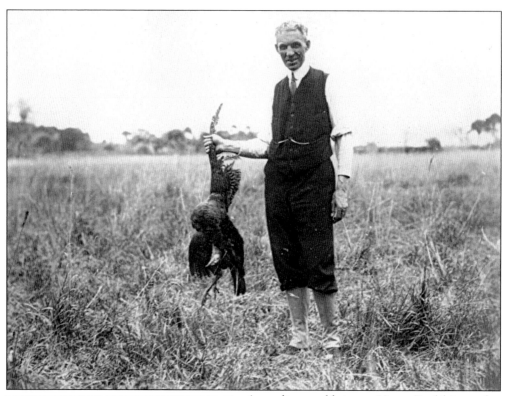

According to old-timers, Henry Ford (pictured above), the famed automaker, had a hunting lodge in the Bonita Springs area. Some say it was the old Walker home, but that has been disputed. Ford and his good friend, inventor Thomas Edison, would reportedly come down from their estates in Fort Myers to hunt in the woods around Bonita Springs. This 1914 photograph shows Ford in the Everglades. (Image courtesy Edison and Ford Winter Estates, Fort Myers.)

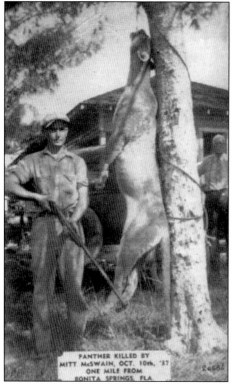

"Mitt" McSwain shot this panther while hunting at night in October 1937 a mile east of Bonita Springs. He was deep in the woods when he turned and saw a pair of wide-set eyes watching him from the underbrush in the distance. Each time he looked, the eyes were closer. Finally, McSwain fired his gun and killed the beast before realizing it was a panther.

This black bear is strung up on what appears to be the back of a tow truck in front of Goodbread's Grocery. The photograph includes members of the McMillan family, early settlers in Bonita. Longtime local residents say the shooting of the bear was probably an isolated incident because black bear were not hunted on a regular basis in the area. The reason for the shooting is unknown.

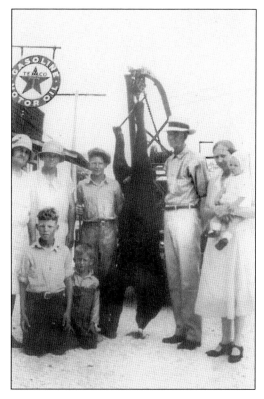

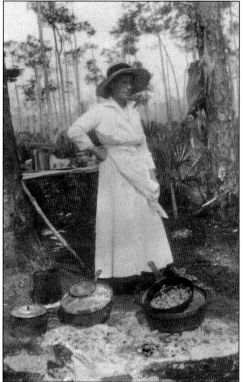

Hunting parties were not just for men. Women often went on the journeys, too. They would stay in the camp, field dress game, and cook food. A typical camp diet would include biscuits and corn bread baked in a Dutch oven, rabbit and squirrel stew, and swamp cabbage. The cabbage is actually the heart of the sabal palm, which was usually boiled and served with meat.

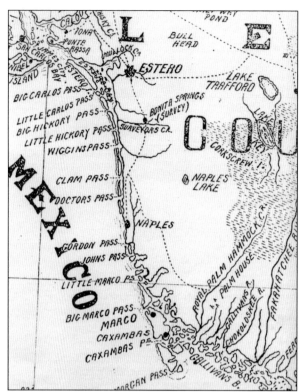

The waters around Bonita Springs—the Gulf, the back bays, and the inland streams—were popular sportfishing destinations. Like the Calusa Indians before them, pioneer families as well as well-heeled visitors turned to the water for sustenance, pleasure, and profit. Mullet, snook, redfish, grouper, snapper, sheepshead, mackerel, and trout were all plentiful. This map is from 1939.

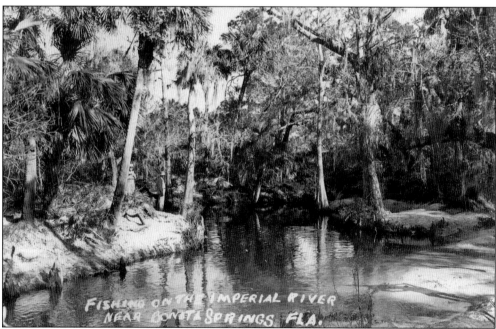

This bucolic image comes from an early-20th-century postcard. It clearly shows the dense subtropical woods and shrubbery that grew along the banks of the Imperial River in Bonita Springs. Palm, oak, and cypress trees hugged the shoreline. Fishing along the river in the shade of these majestic trees was a common pastime in Bonita's early days—a tradition that continues today.

Longtime Bonita resident Haywood Parrish would often tell of fishing on the Imperial River with inventor Thomas Edison, who spent his winters at his home in Fort Myers. The duo would go out into Estero Bay loaded up with fishing gear. Parrish recalls that Edison would bring along milk to drink on the boat. This 1900 photograph shows Edison with his son, Charles, in Fort Myers. (Image courtesy Edison and Ford Winter Estates, Fort Myers.)

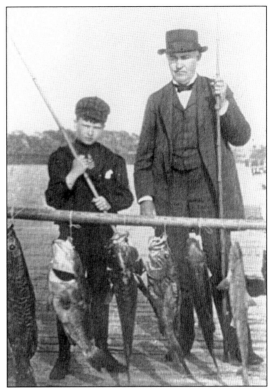

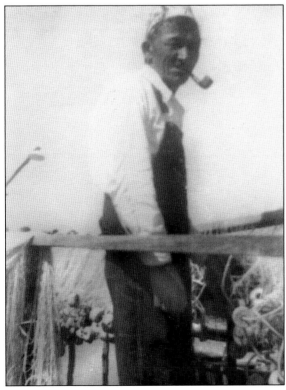

Righdon "R. H." Weeks, a sheriff in Punta Gorda, came to the pristine shores of Southwest Florida in the early 1900s to begin a family fishing tradition that continues today. Weeks, who was a rugged outdoorsman, also owned a farm along Spring Creek with his wife and 11 children. One son, Draine, along with his wife, Mamie, established Weeks Fish Camp at the end of Coconut Road.

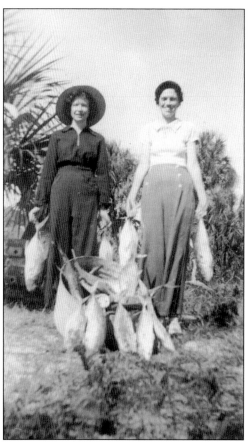

This photograph from 1939 shows Helen Hayes Galloway (right) and a friend with a bunch of amberjacks caught in local waters. Locals say jack was a fish considered not worth eating at that time, and these fish were likely buried next to trees as a Southwest Florida type of fertilizer. Fish were often used as fertilizer near the area's plentiful orange trees.

Oysters, clams, and scallops were prevalent in the waters off Bonita Springs. Jesse Fleming (right) and a friend appear pleased with their harvest. Oyster roasts on the beach were frequent and proved to be a delightful occasion for the town to gather. Serving the oysters with crackers and ketchup was a local delicacy.

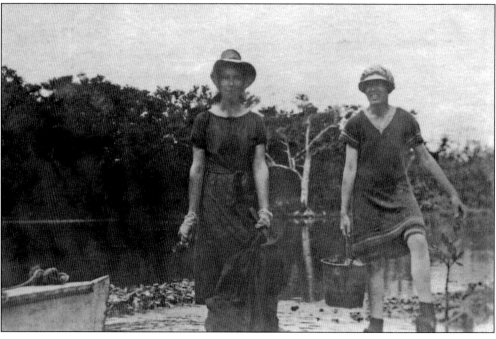

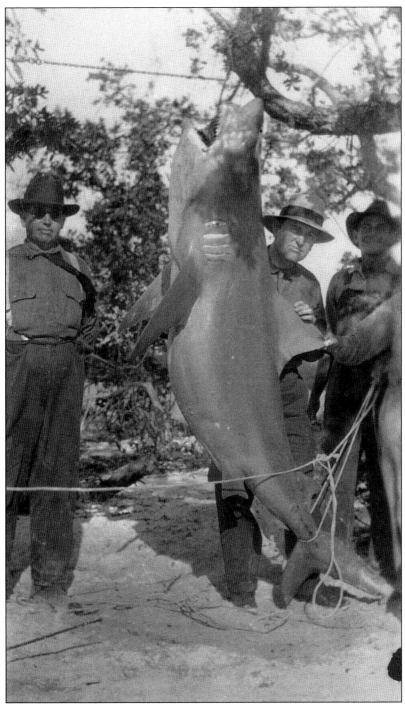

The people in this photograph are most likely tourists. Old-timers say local residents did not wear sunglasses in the early 20th century. While sharks are common in Gulf waters, it was not common to see them reeled in on the beach. Local commercial fishermen avoided sharks because they would tear up fishing nets. As with bears and panthers, this shark might have been a trophy caught by a tourist.

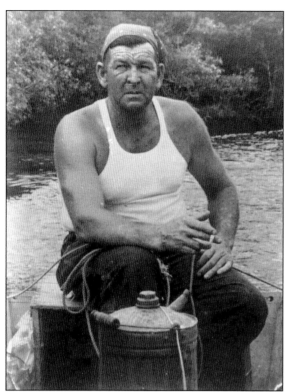

Charlie Weeks, a third-generation Bonita resident, is seen boating in this 1947 photograph. He came from a prominent fishing family in the area. The Weeks family owned the Weeks Fish Camp, an early commercial fishing operation as well as a popular boat ramp and bait shop for fishermen in the area. Today the Hyatt Regency Coconut Point stands near the site of the old Weeks property.

The Mach's Fishing Lodge was located on the northern end of Hickory Boulevard near what is today the Bonita Beach Mobile Village. The owner was named Roscoe Mach, and like other small motels in the area, his lodge catered to the many Northerners who came to fish the rich Gulf waters.

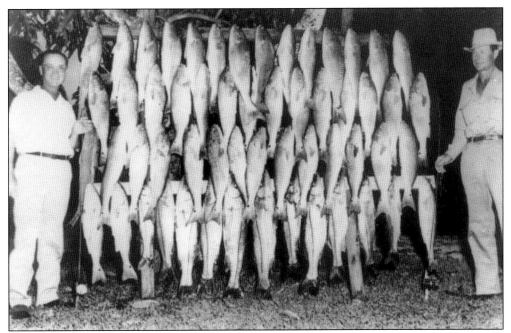

In the early 20th century, fishing stocks along the Gulf Coast were plentiful, and there were few, if any, limitations on fishermen. This 1953 photograph shows tourists Haywood Montgomery (left) and Norman Hutchins (right) after a successful day on the water. The two men reeled in approximately 650 pounds of prized snook and redfish.

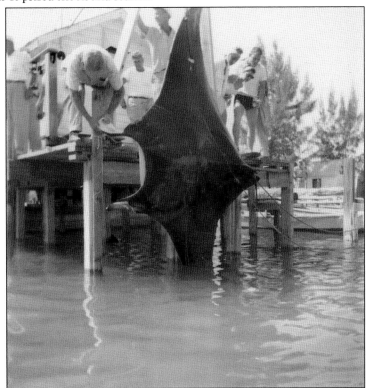

This photograph, taken on what is believed to be the dock at Mach's Fishing Lodge, shows an unfortunate manta ray being hauled out of the water. As with other large game, this was likely a trophy taken by a tourist. Locals say the catch might have been an accident because manta rays are known to avoid the hooks of fishermen.

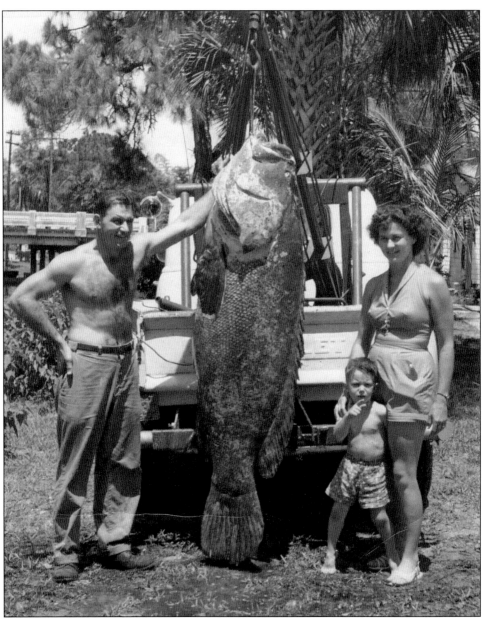

Wendell Gourley, seen in this 1956 photograph, was a prominent business owner in early Bonita Springs. He owned the well-known Imperial River Court, which included cabins, a hotel, and a campground along the banks of the Imperial River in the heart of downtown Bonita. Here Gourley, along with his wife, Ellen, and son, Dan, show off a mammoth 350-pound jewfish caught on a 60-pound test line north of Wiggins Pass. Wendell Gourley caught the fish around late evening and used a chain and Jeep to drag it up the beach. The fish was eventually donated to the Everglades Wonder Gardens, where it was fed to the animals. The jewfish in this photograph is a mere tadpole compared with some recorded catches. The giant fish can grow to more than 8-feet long and can weigh up to 800 pounds. The largest one hooked in Florida tipped the scales at a mere 680 pounds. In 2001, the American Fisheries Society decided to change the name of the jewfish out of fears it could be considered offensive. The new name is now the goliath grouper.

Three
UNDER THE BANYAN TREE

Daily life in Bonita Springs was much like life elsewhere in America—other than the pet alligator on a leash. Grown-ups went to work, ladies tended gardens, and kids frequently swam in area streams, played ball, and went to school. In the evenings, townsfolk would gather near the famous banyan tree to take part in community activities and discuss the latest news.

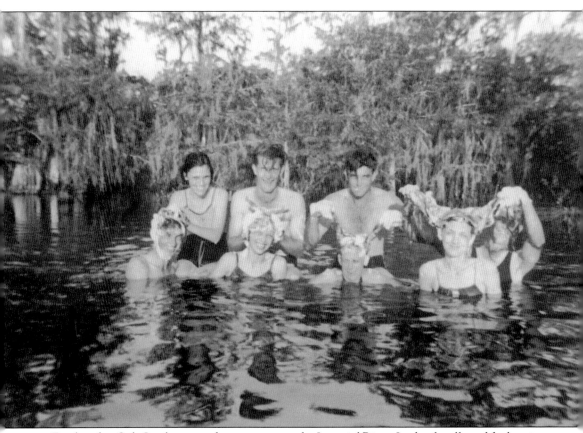

For decades, Oak Creek was used as an access to the Imperial River. Its depths allowed for boating and fishing, and it was a popular swimming hole. Old-timers say families would go down every Saturday to area streams to bathe and wash their hair in the running water. There was no municipal water service at the time, and the water that came up from wells was heavy with sulfur and iron, which was not good for bathing. The woman with her soapy hair being held up is Hazel Hendricks Strickland. Her daughter, Jean Hogue, says that the soap being used is likely Dreft-brand laundry detergent, which locals used for bathing back in the day. Ironically, the town grew up around Oak Creek, which was much more substantial than it is today. Because of recent development and water shortages, it is now so narrow and shallow that it is impassable in some areas.

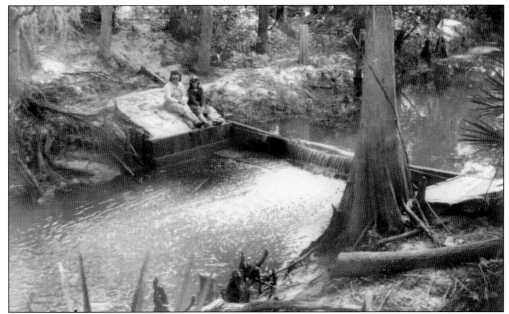
Idyllic settings such as this were commonplace in the little-developed Bonita Springs of the early 20th century. The platform and dam on the Imperial River were built by the South Florida Flood Control agency, later the South Florida Water Management District. Nearby there was a small shed hanging over the river and inside was a water depth ruler. It was Effie Liles's job to regularly check the water level.

Mail was the lifeblood of the remote village of Bonita Springs. It was the main form of communication before the telephone arrived. Postal carriers also brought early settlers dry goods and hardware. Almost anything could be ordered through the Sears Roebuck Company catalog. In the early days, people would begin gathering at the post office long before the mail arrived. Alfred Dickinson, pictured here, served as the postmaster for 30 years.

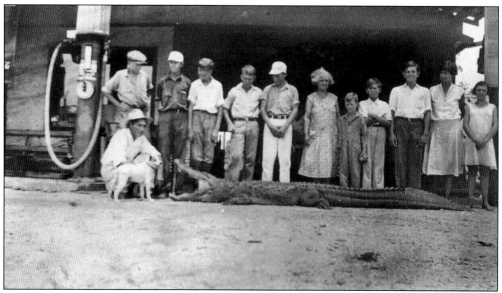

This dead alligator in front of Benson's Grocery was quite a sight and brought a gathering of onlookers into town in 1930. The gentleman with his dog is William Casner. Pictured from left to right are Armond Humphries, George Galloway, Rosco Strickland, Orion McMillan, Vance Strickland, Texa Connell, Carl Shaw, Frank Parrish, John Gray Connell, Ruth Parrish, and Ethelyn Randolph. Many of these people were from pioneer families in Bonita Springs.

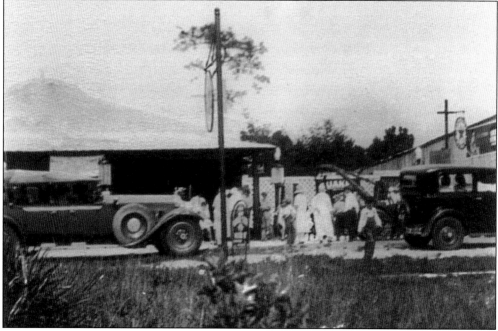

This 1930 photograph of Benson's Grocery shows it as the busy hub it has always been in Bonita Springs. In the late 1920s, T. J. Barnes hired a young man named Clomer Benson to work in his groves. He also drove a truck carrying shell for road fill. Benson ventured into several other businesses, including Mullins Sawmill and the McMillan Garage. This is the building he converted into his eponymous grocery store.

Bonita Springs had a small African American population in its early days. Benson's Lumber had a good number of African American employees who lived at the site. African Americans worked on the railroad and had small homes right next to the tracks. African American women usually worked as domestics—cooks and maids, mostly—at area hotels.

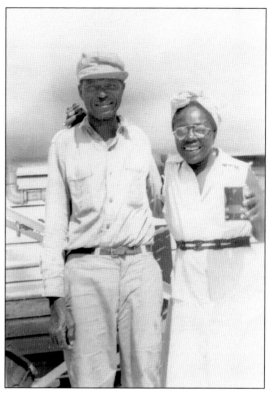

Another group of African American residents in Bonita Springs worked at the rock crusher site and had homes nearby. The rock crusher was where local limestone was pulverized to build roads. The crusher is long gone, and the location is now the home of the Naples–Fort Myers Greyhound Track, which was built in the late 1950s.

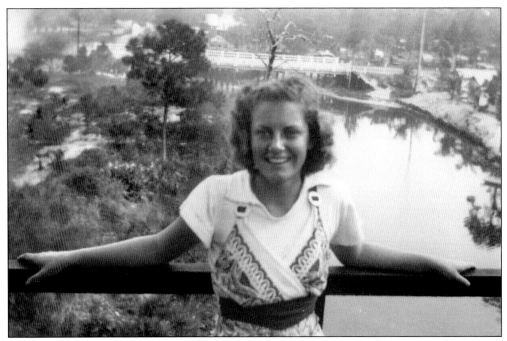

Virginia Schirrmacher, equipped with a box camera, snapped many of the photographs featured in this book. Fortunately, she was not afraid of heights because she climbed to the top of the railroad bridge to take a series of photographs showing the small, rural village that Bonita was in the 1930s. The newly completed Old 41 bridge is directly behind her, and to the left is the Piper property where the Everglades Wonder Gardens are today.

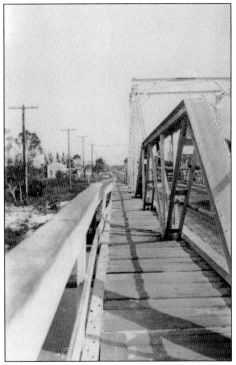

Virginia Schirrmacher took this picture of the Old 41 drawbridge in Bonita Springs. The one-lane bridge with walkways on either side must have appeared wider to motorists. A sign read "Caution—One Lane Bridge," but at least once a year an accident would require cars to be rerouted over a small bridge up river. The building on the left was a gas station.

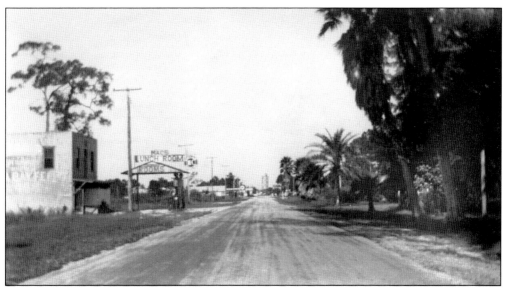

This photograph was taken by Virginia Schirrmacher while standing in front of the Wayside Inn building looking north on Old 41. In the distance is the drawbridge over the Imperial River. On the left there were two locations for travelers to stop for gas and get a bite to eat. The farther building is Lawhon's Grocery. The closer building was Mac's Lunchroom and would be home to many businesses during the next 60 years.

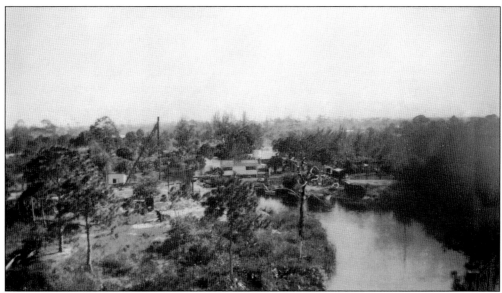

Traffic headaches are visible in this Schirrmacher photograph. The old drawbridge is down, and the pile driver is in place to build the new concrete bridge across the river. Old 41 did not have the first bridge over the Imperial River, but it soon became the most heavily used. An older bridge crossed the river at Imperial Street, near the spot where the original U.S. Army surveyors of Bonita Springs camped.

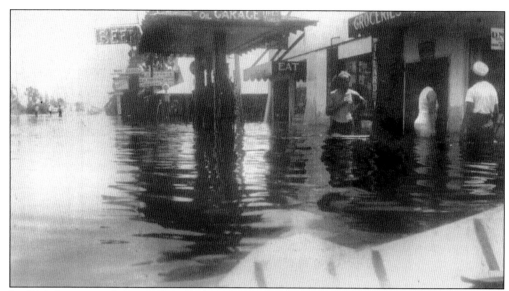

In 1936, downtown Bonita suffered a devastating flood after five days of relentless rain. The river spilled onto Old 41, leaving 3 feet of water, as seen here at Benson's Grocery. People were left to wade or boat around town. The Reahard family lost their chickens to the flood and had to retreat to the roof when knee-deep water rose in their home.

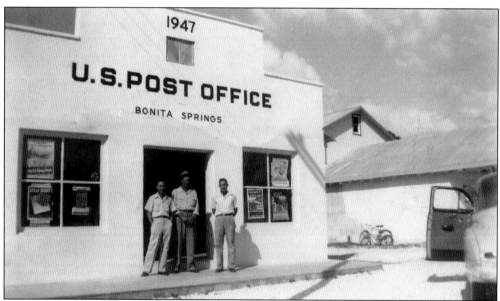

Glenn Liles (right) was the Bonita Springs postmaster for 30 years, from 1942 to 1972. He loved his job because he got to know everyone in town. Liles would often recall how he and his staff tried to get every package delivered before Christmas Eve and would even make last-minute attempts Christmas morning. The other gentlemen in this photograph are Vance Strickland on the left and Gary Hogue in the center.

This old Bonita Springs water tower originally sat on the northwestern corner of Old 41 and Bonita Beach Road. When construction of a gas station at the site began in 1985, the tank was carefully removed and saved. (Coincidentally, a gas station had operated at this same location in the 1940s.) One of 10 similar water towers once found around town, this survivor sits atop a new structure in Riverside Park.

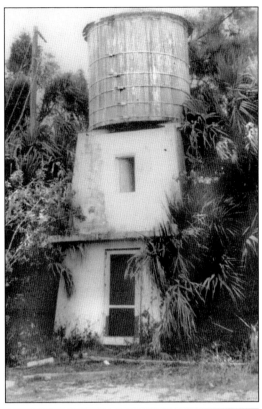

These men were volunteers at a time when Bonita Springs firefighters were lucky if they had helmets and boots. Fighting this brush fire are (from left to right) George Ingram, Pat Black, Bill Horne, Don Trew, and Don Cooley. It was not until the late 1970s that firefighters got paid, as well as proper training and equipment. The old fire truck is still a popular entry in Fourth of July parades.

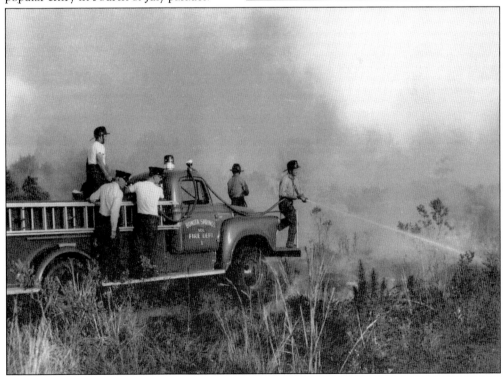

An English gentleman named Harold Thomas purchased land along the Imperial River west of town. A small community known as Thomasville sprang up and included 30 homes, a store, and a sawmill. This photograph shows the Uzzell brothers at the Thomasville diving board on the river. A hurricane that damaged Thomasville in the 1920s and a forest fire, which swept through town, marked the end of the community. Today the property is home to the Bonita Bay development.

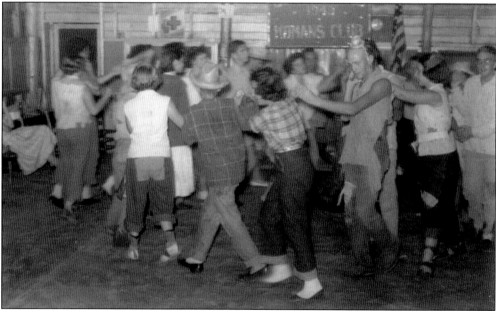

As Bonita Springs grew, many social gatherings took place next to the banyan tree in the building known as the pavilion. Built around 1900, this rustic structure typically held events such as weddings, political rallies, and club meetings. This dance in 1954 was well attended by Bonita's youth. The old pavilion was razed in 1963, and a more modern structure was built at the site. Today it is known as the Community Hall.

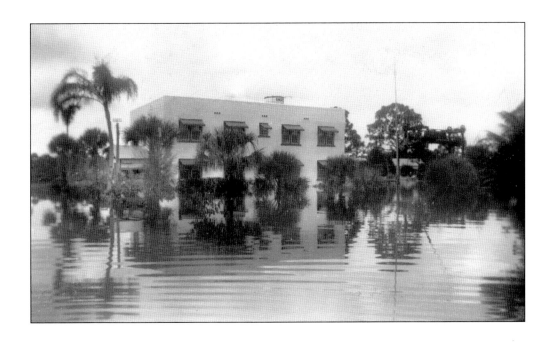

In 1951, heavy rains caused the Imperial River to top its banks, leaving two popular campgrounds, Imperial River Court (IRC) and Doc Baird's, underwater. To the right of the Liles Hotel (above), which was part of the IRC, is the railroad bridge over the river. Upriver, Baird's campground activity center (below), built on pilings, is surrounded by swift-moving water. The Liles Hotel survived several floods as well as Hurricane Donna, and today it contains exhibits and resources of the Bonita Springs Historical Society. Doc Baird's building survived the 1951 flood but closed in the 1960s, and no remnants of the campsite are found today.

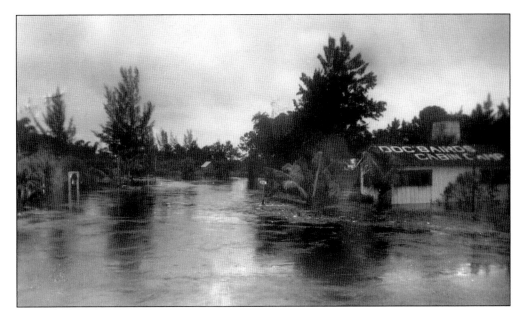

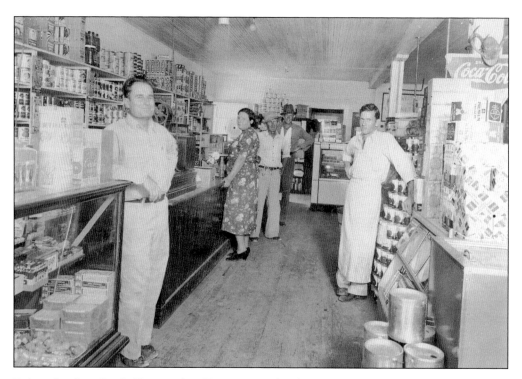

Robert Lawhon Sr. (left) arrived in Fort Myers, Florida, with little more than pocket change to manage a gas station. Seeing an opportunity in the small community of Bonita Springs, he opened Lawhon's General Store. Pictured in the long white apron is Pete Peters, the store's butcher. Lawhon's General Store was situated on the west side of Old 41 across from Benson's Grocery. Lawhon supplemented his income by working at farms, groves, or sawmills. Over the years, he acquired quite a bit of property around Bonita Springs. He and his wife, Shellie, contributed greatly to the growth of Bonita Springs.

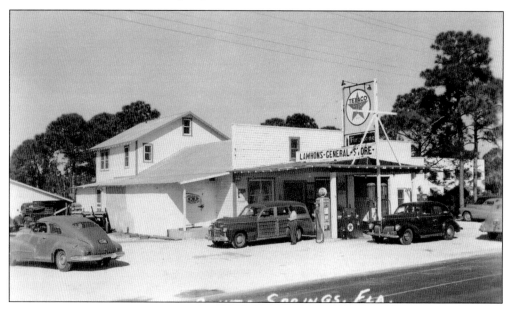

During World War II, servicemen came to train at local facilities such as the Buckingham Air Base, Page Field, and the Naples Airport. Many of them, such as this man on the beach, came to Bonita Springs for a little R & R. Local residents remember blackening their windows at night lest an enemy plane spot the light. Car headlights were painted with a black stripe across the top so light would not shine into the sky. The Bonita elementary school held air raid drills with sirens piercing many quiet mornings. Resident Jean Hogue remembers the school building shaking as depth charges exploded in the nearby Gulf of Mexico. In front of Lawhon's Grocery Store, there was a small shed filled with photographs of enemy planes. Area men studied these images and spent time watching the skies as "spotters" ready to call in suspicious sightings.

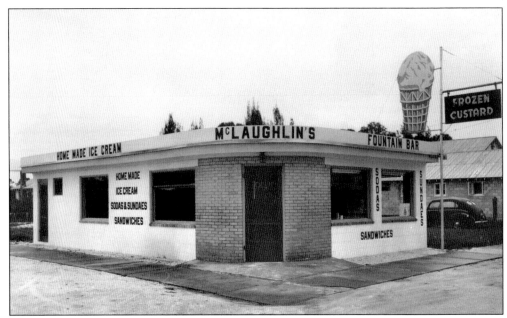

Built in 1949, this unique art deco–style building was first known as McLaughlin's and later as Zaks. It was a hangout for local teens wanting a soda or ice cream and a place to meet. Many tourists to the area would also stop in to cool off. Located next to the old ballpark on Old 41, the restaurant was also a popular place for after-game treats. The long counter was lined with red swivel stools, and the menu included a questionable liverwurst sandwich. There was a jukebox and pinball machine. The shop also sold magazines, postcards, and comic books for the kids. Every year, local teens would borrow outhouses from people's backyards and place them in front of downtown Bonita businesses. The ice cream shop was often a target. Currently, the building is a realty office.

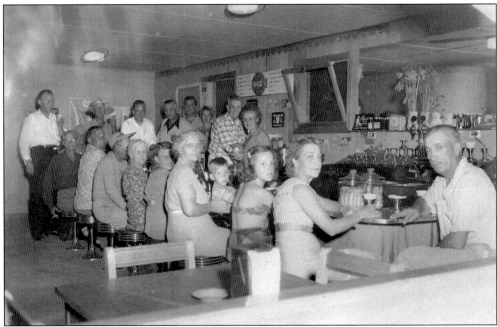

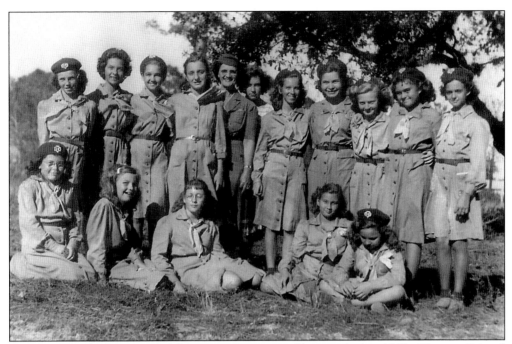

Bonita Springs had its own Girl Scout troop, as pictured here in the late 1940s. Their traditional green uniform included a button-down belted dress with lapels, scarf, and a beret. The new *Girl Scout Handbook*, published in 1947, featured a new focus on agriculture with badges such as "Poultry Raiser" and "Beekeeper"—nothing new for the girls of Bonita Springs.

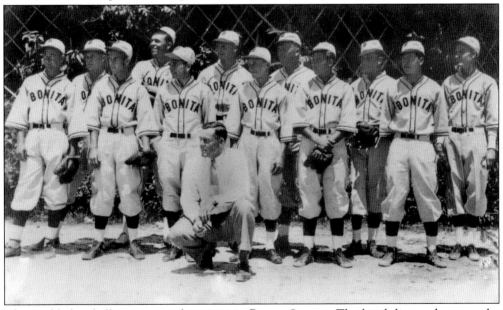

The weekly baseball game was a big event in Bonita Springs. The local diamond was on the southeast corner of Terry Street and Old 41. Everyone in town attended. Ladies visited and gossiped. Children played tag, got dirty, and finished the day with a bath in the river. The hometown team played Naples, Everglades, LaBelle, and its big rival, Estero. Clifford McSwain is the coach in this photograph.

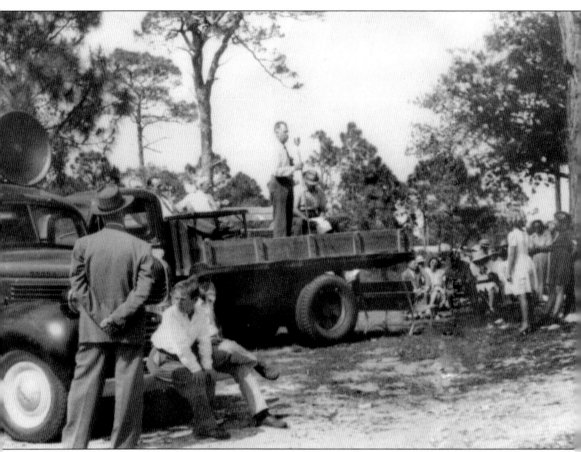

This photograph shows a political rally for sheriff's candidate Flanders "Snag" Thompson taking place at the pavilion in the heart of Bonita Springs. Campaigning from the back of trucks and addressing crowds in area parks were common in the days before television advertisements became widespread. Thompson was a well-known figure in Lee County. He served 24 years as sheriff, from

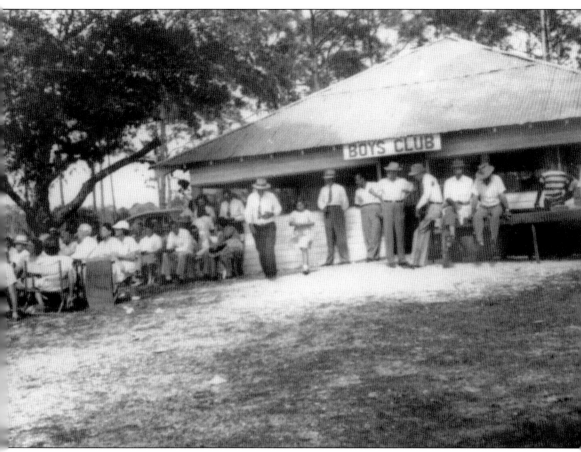

1949 to 1973. He was also known for his work as the founder of the Sheriffs' Boys Ranch and Lee County Little League. He was a veteran of World War II and was considered a high-ranking Democrat in Florida politics. (Locals say the men dressed up in suit pants, ties, and hats, standing near the pavilion, are likely other local politicians who came to the rally.)

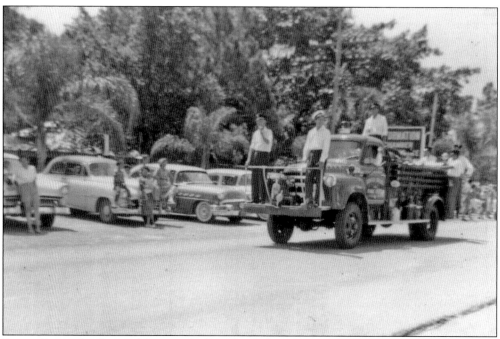

Bonita Springs has been celebrating the Fourth of July with a parade down Old 41 for decades. Fire trucks, floats, children on bicycles, and decorated vehicles show their pride and sense of tradition. The Bonita Springs Fire Department's original Brush Fire Truck No. 1 has always been a popular feature in the annual parade. The vehicle was recently restored and has a permanent home in the town's first fire station, located on Old 41. This car below promoted the local library, which was founded as a book swap by the Bonita Springs Women's Club and was originally housed in a beauty salon. The library eventually moved to a small building on Pine Street.

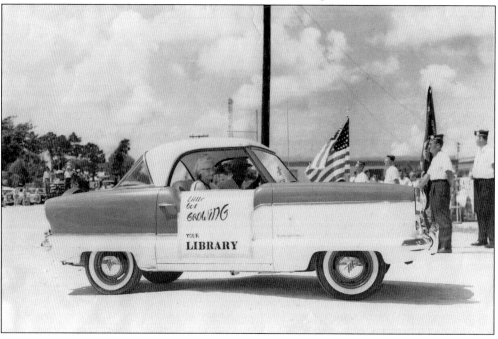

Four
GATEWAY TO THE GULF

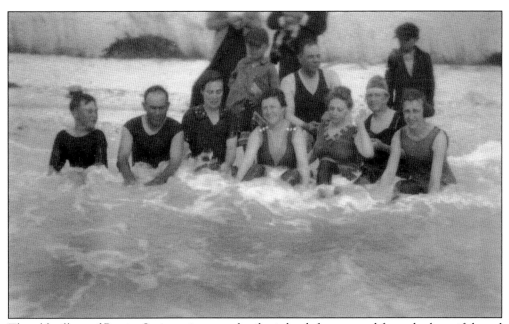

The old village of Bonita Springs sits several miles inland, far removed from the beautiful sand beaches of Bonita Beach. Nonetheless, the histories of the two areas have long been intertwined. From the early beach cabins and rustic fish camps, to the development of Bonita Beach Road and the shoreline mansions of today, Bonita Beach has long beckoned to locals and visitors alike.

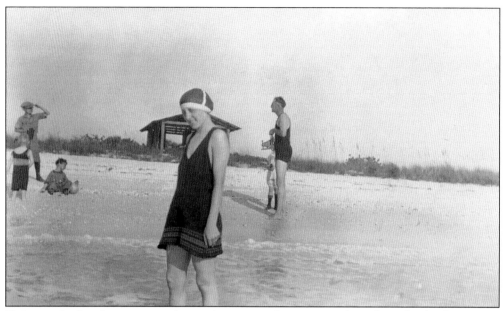

Going to the beach was once a long trip over poorly maintained sandy trails. At the current Bonita Shores area, there was a footbridge past a long-gone Indian mound across the bay out to the beach. It was an all-day affair, and families would take provisions to make dinner right on the beach, including fish caught by the men and the ubiquitous swamp cabbage. A tin shed on the beach served as a dressing room.

This photograph of the Barnes and Randolph families was taken at Bonita Beach. Both families were early settlers of Survey and were often seen together. At one time, the pavilion was the only visible structure along the vast stretch of sand and sea oats. In the days before the invention of sunscreen, pioneers knew to protect their skin by wearing long sleeves and light-colored clothing.

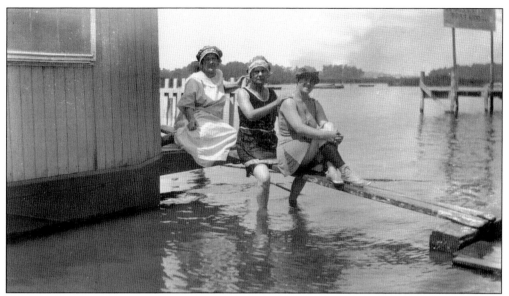

In 1923, these women posed alongside this boathouse located on the bay waters of Bonita Springs. Swimwear of the 1920s typically included a cap and skirt of suitable length. The three women in the photograph are believed to be sisters Ruth Baird (left), the wife of local businessman Doc Baird; a Mrs. Harris, a teacher at the Bonita Springs elementary school; and a Mrs. Conant, an opera singer who lived in Fort Myers.

This shark drew a crowd on the beach of some 25 people—young and old alike. Whether caught by a fisherman or just washed ashore, the six-foot nurse shark caused plenty of excitement, which was enough for people to take pictures. It is better to meet this fish on land rather than in the water, though a nurse shark is not usually a threat to people.

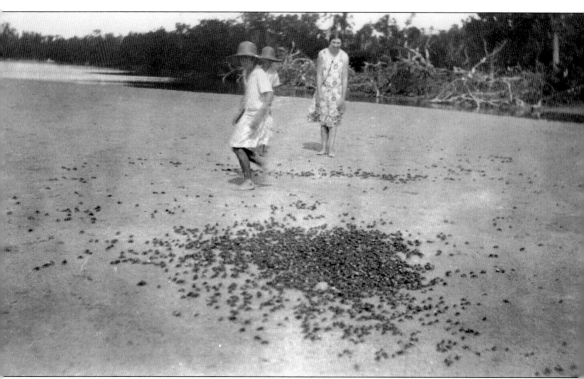

Bonita Beach was once referred to as "Fiddlerville" when more fiddler crabs called it home than people. The salt marshes there provided a perfect habitat for the fiddlers. The crabs got their name because of the way their claws move while eating—the movement resembles a musician playing a fiddle. These three young women are surrounded by fiddler crabs in this 1930 photograph. Locals would bury a bucket in the sand and run in a circle around the swarms of crabs. This would cause the crabs to bunch up and surge like a school of fish all moving in unison. As the circle got tighter and tighter, the crabs would begin to fall into the bucket. These crabs would usually wind up as fishing bait. Longtime resident Helen Galloway hated driving to the beach because there were so many crabs on the road, she could not avoid them. While fiddler crabs can still be found on Bonita Beach today, their numbers have dropped significantly, and scenes like this are a thing of the past.

During the 1920s, Bonita Beach was as remote a location as anywhere in Florida. The 14-mile stretch of beach was wide, and homes were few and far between. The vegetation was mainly grasses, and Australian pine trees were found up and down the coastline. The Bonita Beach area was named Hickory Island.

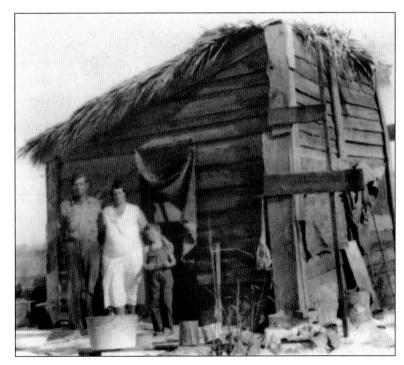

This old photograph of Charlie Weeks, his wife, Hazel, and her son, Elbert Gant, shows an early Bonita Beach house. The 10-square-foot thatched-roof structure with sand floors was located on the northern end of Hickory Boulevard, which paralleled the beach. Members of the large Weeks family, with deep roots in the Bonita area, enjoyed visiting their Uncle Charlie.

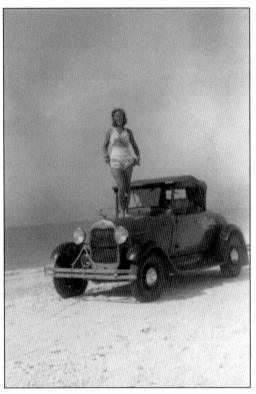

This photograph depicts the true spirit of the beach—a place to frolic and have fun—even if that meant posing on top of a vintage car. Taken in the 1950s, the image would have been a good advertising promotion for Bonita Beach. However, unlike Daytona Beach, where cars were commonly seen near the water, Bonita Beach developed as a residential strip, and driving along the shoreline was not encouraged.

These steel pilings led to a rumor that a railroad once extended to the beach. In truth, Walter Mack, who owned what is now Lely Barefoot Beach, bought sections of railroad track in the 1940s. He had them pounded into the sand at the county line to keep cars off the beach. Buried as deep as six feet, the shifting sands have buried some while others have since been removed.

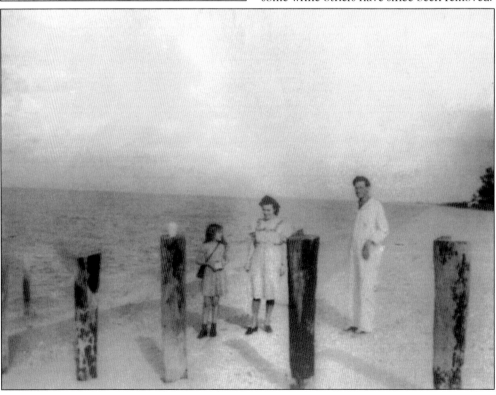

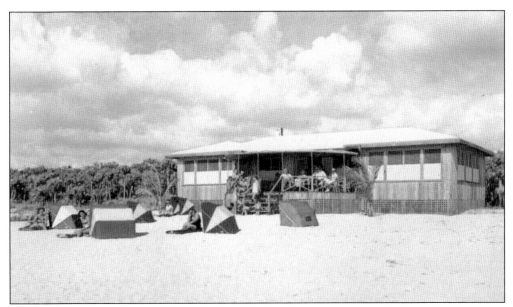

The Villa Bonita Hotel featured this Cabana Club amenity for its guests. Accessible by road or by the river, guests could enjoy a day at the beach in addition to the rest and relaxation of the resort on Old 41. The building would sometimes become the site of impromptu late-night parties when beach-strolling residents of Bonita Springs would find it empty. It was damaged during Hurricane Donna in 1960 and was eventually demolished.

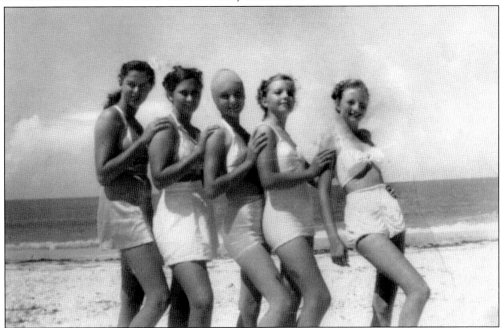

These 1949 bathing beauties are, from left to right, Betty Parrish, Irene Knottingham, Jean Strickland, Betty Liles, and Minnie Metcalf. While farther east, Bonita Springs was growing in these postwar days, the beach remained undeveloped at the time. As in earlier years, Bonita Beach was still primarily a spot to swim, sunbathe, and fish. The many large homes and high-rise condominiums were still decades away.

During the 1950s and 1960s, the beach became more accessible and drew large weekend crowds with the development of Bonita Beach Road. A few restaurants had popped up along Bonita Beach Road as well as gas stations and convenience stores. Fishermen could also find bait shops. The old footbridge to the beach was replaced with a modern concrete structure in 1958.

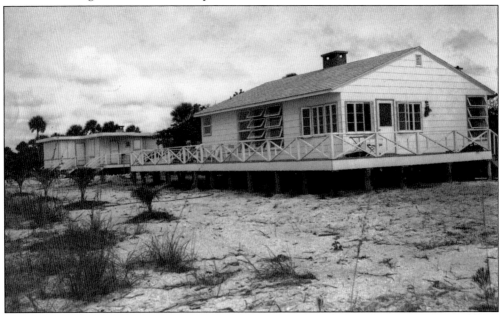

Kinley Engvalson and his wife, Carol, spent their first winter in Bonita Springs in 1939 and built this home shortly after Hurricane Donna in 1960. Engvalson developed beach- and bay-front properties along Hickory Boulevard. He also deeded the land for the nine beach access points that are still in use. Today most of those quaint beach homes are long gone—replaced by multi-million-dollar mansions.

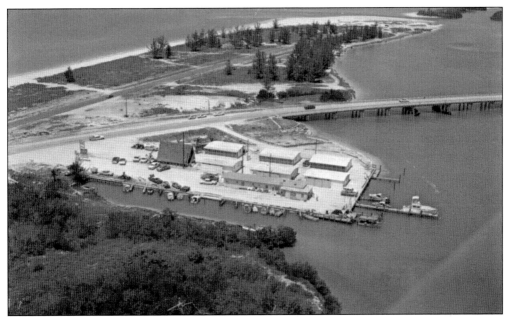

On the north end of Hickory Island, a small commercial village sprang up in the 1960s. Tourists and boaters could stop for fuel, food, and other supplies. Located on the east side of Hickory Boulevard, the popular Big Hickory Seafood Grille, owned by the Bode family, would serve guests for many years. The then-still-undeveloped tip of the island can be seen in this photograph. It was a favorite fishing location until high-rise condominiums were built in the 1970s.

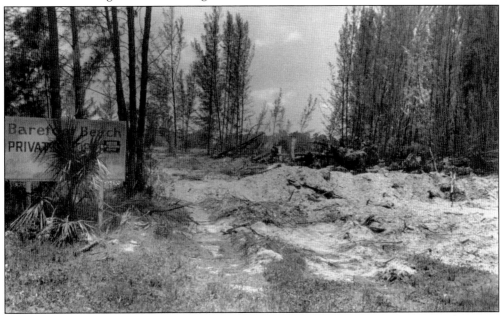

After many changes in ownership, Barefoot Beach finally began to see development in the 1970s. The entrance, pictured here under construction, would become controversial when homeowners and beachgoers clashed over access. The towering Australian Pines came down, and the millionaire mansions and condominiums went up along the southern side of Bonita Beach Road. A winding road now leads to the beach, which is a popular spot for sunbathers.

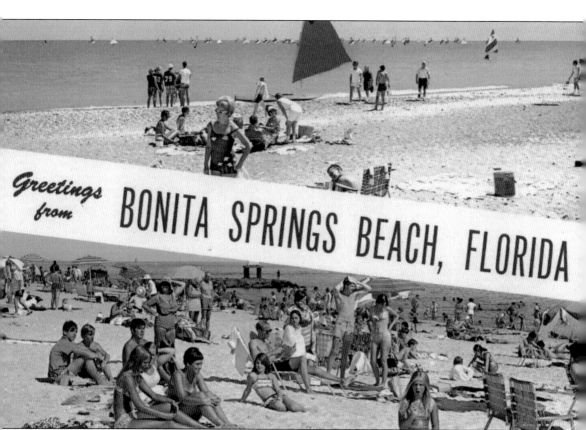

This postcard refers to the beach as Bonita Springs Beach. This was an uncommon name for Bonita Beach and was probably the work of a copywriter at the postcard company. In fact, there is some question as to whether the crowded beach scenes were really taken on Bonita Beach. The beach is so long and so large that sunbathers and swimmers are rarely bunched together like in these photographs. Nonetheless, the beach has always been popular. As access to the beach improved, it was not just locals who found their way there. The tourists crowding the roadside attractions back in the village of Bonita Springs soon found this natural attraction just a few miles away. Today tourists are still coming to the beach. Now they can play volleyball and rent personal watercraft to ride the waves at Bonita Beach.

Five

TIMBER TO CUT, GROVES TO GROW

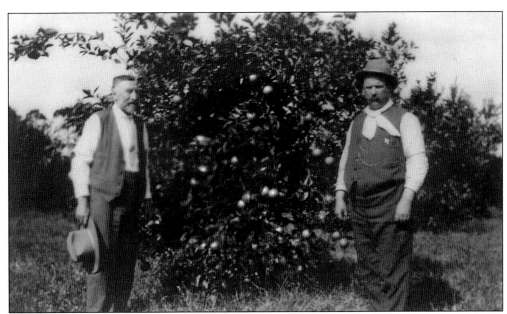

The Bonita Springs economy has always walked in step with Mother Nature. From timber to citrus, from fishing to hunting, sunshine and warm temperatures are the engines that have powered Bonita's growth. Citrus crop freezes in northern Florida led many growers to move south. The sandy soil here proved to be excellent for agriculture. The gentleman on the right is J. Quinn, who was a prominent landowner. The other man is unidentified.

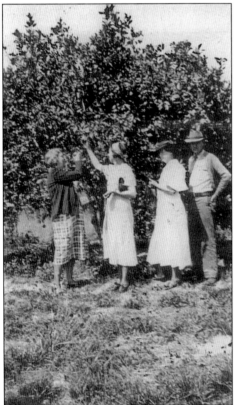

Bonita Springs was a good location for groves because of its proximity to the Gulf waters. Communities farther inland experienced more loss from frost. During cold spells, owners like James McMillan, pictured here, would turn on their wells to let the water cover the crops. The water would freeze, creating a rime, which protected the delicate plants from the cold.

Whether visitors or residents of Bonita Springs, people have enjoyed Florida citrus for more than a century. Bonita Springs boasted that its grapefruit could not be beaten in quality. A 1920s local Board of Trade booklet stated that more than 300 local acres were producing fruit. Common varieties of oranges grown were Valencia and Pineapple. Ten acres was considered an average-sized grove.

Many types of agriculture were important to the economy of Bonita Springs. While the census of 1900 lists most area residents as citrus farmers, other crops were also common. Avocado, mango, strawberries, guava, papaya, sapodilla, kumquat, banana, pineapple, pecan, and coconut trees were grown. Farmers also grew sugar cane. Some longtime residents still lament the absence of the popular guava trees.

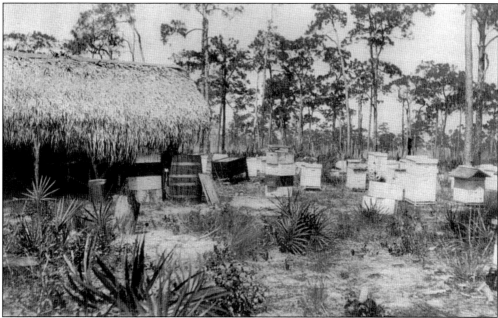

Bee culture was profitable in Bonita Springs. The delicious honey of the area was made with sweet nectar from citrus and palmetto blooms. This bee apiary was located in East Bonita and was owned by the Johnson family. Another Bonita pioneer, Felix Uzzell was honored by the Florida State Beekeeper Association for his contribution to the profession.

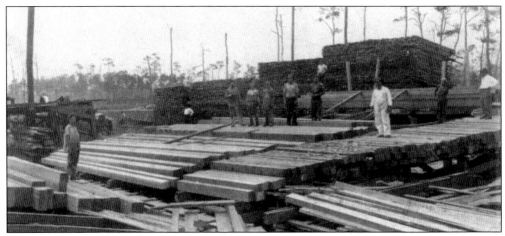

Sawmills, such as the Strickland Mill seen in this photograph, did a thriving business in the early days of Bonita Springs. The densely forested area was filled with cypress and pine trees. The huge mounds of sawdust produced by the sawmills were used to fill ruts in the early sand-and-shell roads in the area.

Benson's Lumber was owned by the same family that once ran a garage, restaurant, and market in the location of Benson's Grocery. Another sawmill, located north of the Imperial River, featured a store and some 30 homes. The community became known as Thomasville, named after Harold Thomas, a prominent figure in early Bonita history. According to local lore, a hurricane and a forest fire wiped out Thomasville. Today no trace remains.

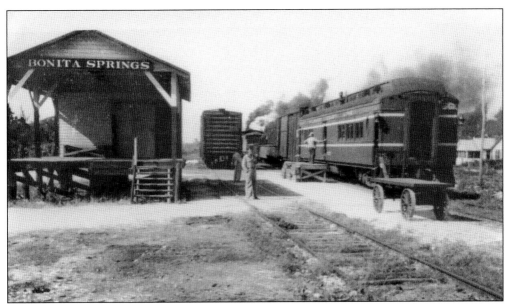

In 1922, the Fort Myers Southern Railroad Company made plans to extend service to Bonita Springs. The company built the first depot here in 1925. This service was part of the Atlantic Coastline (ACL) system. In 1936, a heavy rainfall washed fallen tree limbs and other debris into the Imperial River. This material ran into the Atlantic Coast Line train trestle and created a massive dam. The rising waters flooded downtown Bonita Springs. Residents took rowboats to pick up groceries and navigate around town. Business owners threatened to dynamite the trestle unless ACL officials raised the bridge, which they ultimately did. At one time, a rival railroad company, the Seaboard Coastline, ran parallel tracks to Bonita, but ultimately, it could not compete and later removed them. In 1960, the Bonita Springs depot collapsed due to damage from Hurricane Donna.

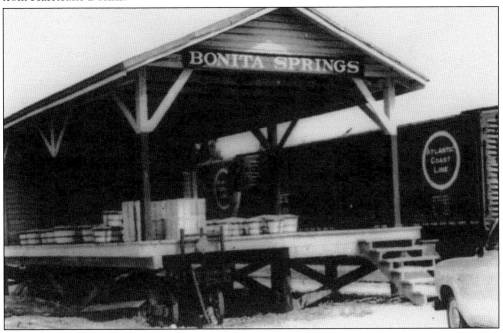

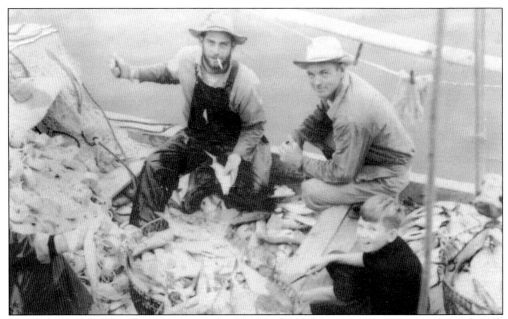

Franklin Weeks (left), a third-generation member of a family fishing dynasty, sits atop his catch with an unidentified friend and a boy. His father, Draine, and mother, Mary Angeline (Mamie), reared him and his nine siblings in the little village of Coconut. Commercial fishing was an important part of the economy of Bonita Springs, and Weeks carried on this pioneer tradition—fishing local waters, surviving storms, and helping stranded boaters.

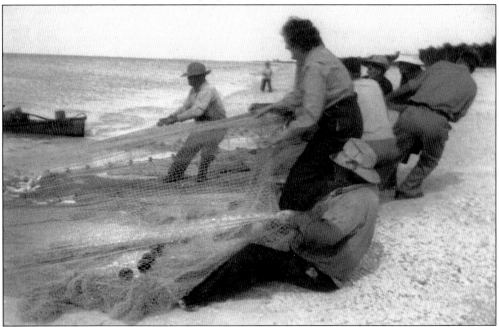

Hub Johnson was so wet and tired from hours in the water, all he could do was sit on the beach. Along with friends, they were able to land this mass of mullet and then scoop them into his boat. The process was worth it because mullet was a marketable catch. Silver mullet was used as bait fish, while black mullet was considered best for eating.

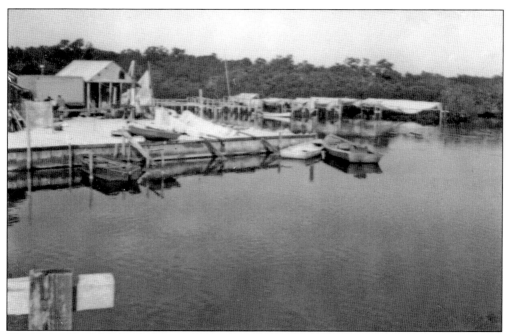

This commercial fish house, pictured around 1940, was located at the end of Coconut Road. The Johnson and Weeks families lived in this remote area along the back-bay waters surrounded by winding channels through mangrove forests. Before the introduction of nylon, fisherman used natural fibers to make their nets, which required a large amount of maintenance.

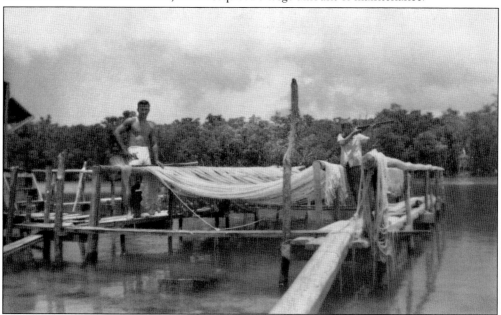

Net spreaders were a common sight in a commercial fishery. After a day's work, large gill nets were put through a process of liming that helped slow deterioration of the fibers. The nets were then spread out to dry. Nets of this type required frequent repairs. A skilled fisherman became adept at mending his nets using special tools in much the same way the Calusa Indians did centuries before.

In 1912, a group of investors formed the Bonita Land Company. These developers saw great potential for Bonita Springs and wanted to turn it into a modern city. The company helped bring new electrical infrastructure to Bonita Springs as well as the railway station, post office, city park, and baseball park. It used this long-gone building next to the Wayside Inn as its office.

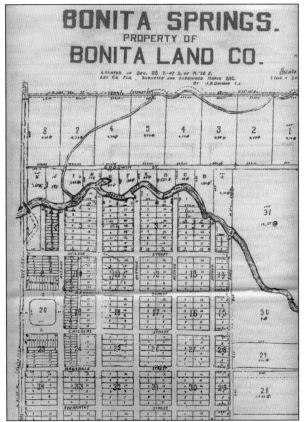

This photograph shows the plat map of 1912. The shareholders of the Bonita Land Company, led by J. Henry Ragsdale, chose to name roads after themselves. The 56 blocks were divided up with streets running east-west and avenues running north-south. John Dean, a prominent businessman in Fort Myers, lent his name to the southern boundary with Goodwin as the north boundary, Heitman in the west, and Coon in the east.

In 1920, the Board of Trade in Bonita Springs was established and published a booklet promoting the little town. It was printed by the *Tropical News*, which later became part of the *Fort Myers News-Press*. Dubbed "The Garden Spot of Florida," Bonita Springs had a population of approximately 150 at the time. The booklet is one of the most important documents in the local historical society's archives.

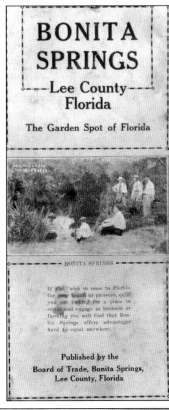

This home was moved across the bridge at Old 41 in 1949 to make way for a commercial building. Monica Hunt bought it from Ona Watkins Hendricks and had it moved up near what locals called the "condemned bridge," a closed bridge over the Imperial River that was a landmark for decades. Notice the water closet on the side of the house, which serves as a sign of the days when indoor plumbing first came to Bonita Springs.

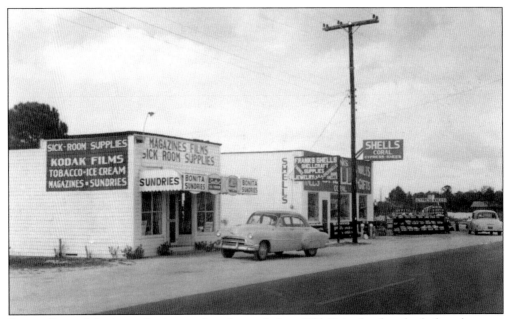

Bonita Springs's business district was long located along Old 41 in the decades before the town expanded toward the beach. The architecture of the day was not ornate but rather functional. Some of these businesses, seen in this c. 1950s photograph, catered more to tourists passing through than to the townsfolk. The usual trinkets and necessities were available at a time when few stores would be found between Fort Myers and Naples.

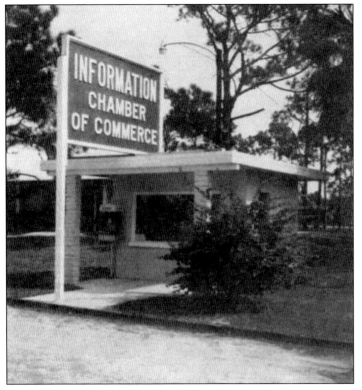

This tiny brick building sat in front of the Bonita Springs Community Hall and the banyan tree. It served as a welcome center of sorts, dispensing information to tourists passing through Bonita Springs. As real estate sales boomed, the chamber of commerce moved to a succession of larger buildings. In later years, sandwiches and pizzas were sold in the little brick kiosk.

Six
"You Can Pitch a Tent Here"

Bonita Springs boomed in the early 20th century, and tourism grew. This bellhop sign stood in front of the Bonita Court. Its arm went up and down, and the tip of its cigar glowed. A family traveling in the area stopped in Naples to camp for the night, but townsfolk sent them packing. When they arrived in Bonita Springs, locals told them "you can pitch a tent here," which is a perfect symbol of the hospitality that has greeted visitors for decades.

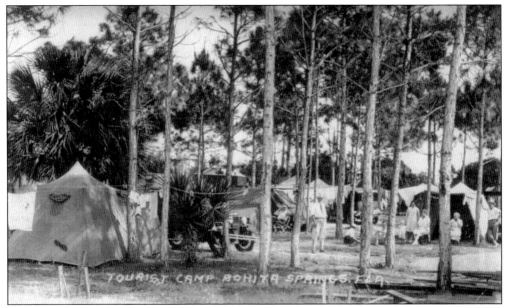

Virginia Schirrmacher and her parents were the family that was invited to stay. They came to vacation in Florida in the late 1920s from Michigan. As they drove from Miami to Naples along the completed but rocky Tamiami Trail, it was time to call it a night. Naples did not allow tent camping, and the family was told to go farther north to Bonita Springs. There they found Doc Baird's, a well-known campground, and fell in love with Bonita Springs.

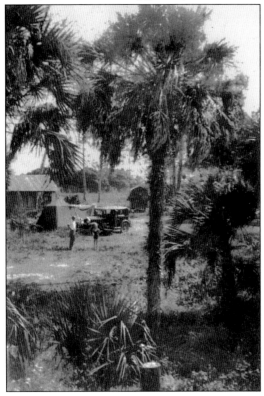

Virginia Schirrmacher is pictured here at the age of nine with her father, Emil, at their Doc Baird's tent site. The family car, an Essex, brought them to Bonita Springs for many years, and each time they stayed a bit longer. The building was known as the Cook House because Ruth Baird had equipped it with an old, World War I–era, wood-burning stove. On cold nights, it was a popular gathering place.

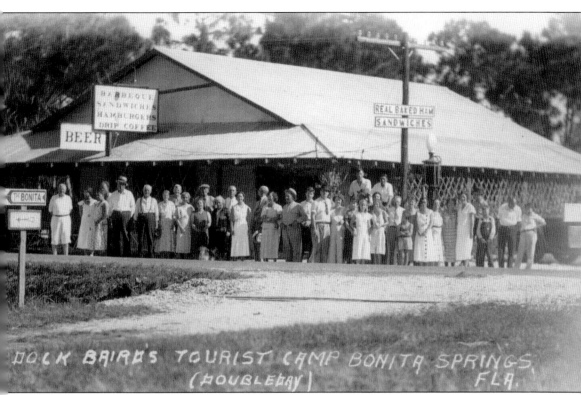

Mr. and Mrs. Archer Baird had come to Bonita Springs from Boston in 1925. Ruth Baird had been a professional singer, and "Doc" Baird had been a baseball player. The couple purchased land on the south side of the Imperial River, where they built Baird's Tourist Camp. The interior of their popular tavern was finished in natural hardwood, and on the ceiling, split hibiscus sticks were made into frames surrounding Native American good luck symbols. Live music on Friday and Saturday nights brought a livelier crowd to the honky-tonk bar, which had a wild reputation. Many of Bonita's more upstanding citizens looked askance at the bar and forbade their families from going there. Doc Baird's had frequent visits from well-known ball players during the years when the Philadelphia Athletics were in Fort Myers for spring training. Hall of Fame player Jimmie Foxx was a visitor to the tavern.

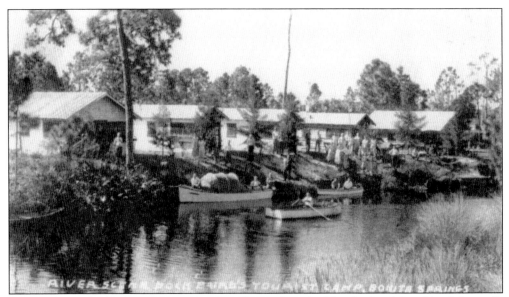

The lumber to build the cabins at Doc Baird's was furnished by the local Strickland Sawmill. Visitors could rent the cabins for a night, a week, or the season, and some rented year after year. There was electricity but no indoor plumbing. Doc Baird is pictured in front of the cabin on the far left. Baird's cabins were located up river from those of the Imperial River Tourist Court.

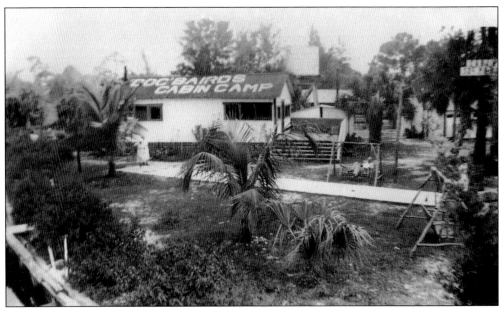

This picture was taken from the Old 41 Bridge looking down at Doc Baird's camp. In the lower left is the river where campers could tie up their boats. The shuffleboard court in the center was a popular place to pass the time. The community building was used for playing cards and bingo. Cabins were priced at 50¢ per person. The Everglades Wonder Gardens is across the street.

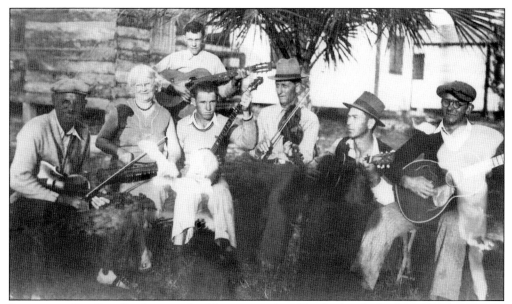

Evenings at Doc Baird's often involved live music played by the locals. In this 1932 photograph, Bill Piper (second from right), co-owner of the Everglades Wonder Gardens, is playing guitar. Some nights, his brother Lester would play mandolin. During the winter months, people would scatter corn meal on the tavern floor and then use it as a dance floor.

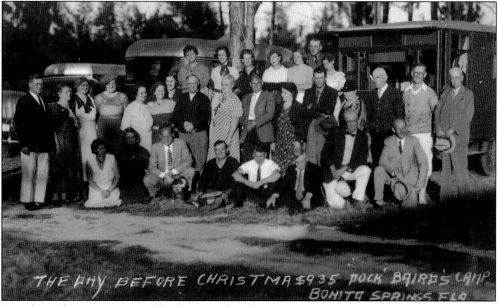

Spending Christmas 1935 in Florida seemed to please this group of visitors at Doc Baird's camp. Sunshine, warm temperatures, and a friendly community kept guests returning to this popular tourist retreat year after year. Baird's campground afforded its guests a slower pace of life among the natural beauty of Southwest Florida. Tourists, also known as "tin-canners," came to Bonita Springs in travel trailers such as those seen in the background.

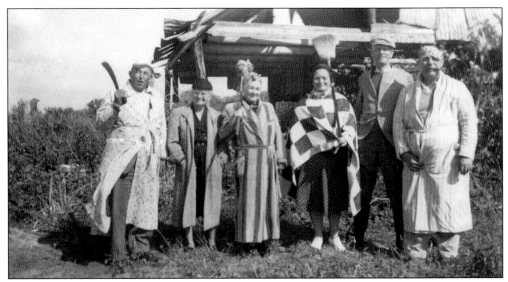

Many tales have sprung up about Baird's Tourist Camp. Apparently, Ruth Baird liked to drum-up business and convinced many southbound travelers to stay at her campground for the night rather than risk the dangers that lay ahead should they be caught in the Everglades at night. Other, sillier dangers lurked around the cabins at Doc Baird's, such as these vacationers dressed as pirates.

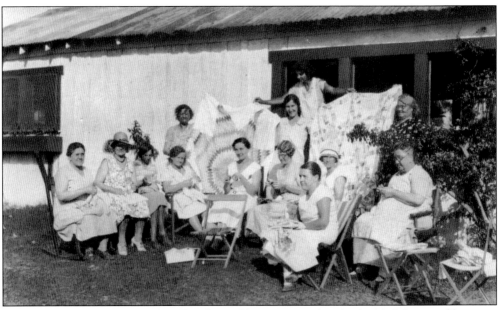

While some women staying at Doc Baird's would accompany their husbands fishing and hunting, others spent their days quilting. Quilting bees go back to at least the 1800s, when women would gather around a wooden frame to stitch while sharing stories, recipes, and advice. The beautiful Florida weather allowed the women to gather outside in large numbers to work on their quilts, like these ladies pictured here in 1930.

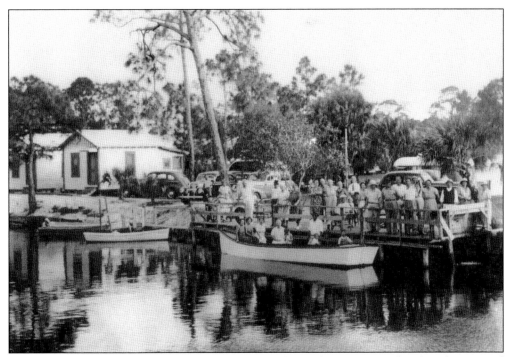

The Imperial River Tourist Court, built by James Wallace Liles, was a popular place for seasonal visitors and overnight guests lured by the promise of premium fishing. In this famous local photograph from the 1940s, guests gather at the Imperial River with cottages behind them. The cottages were located along the southern bank. Six of them were saved, and today they sit near their original site.

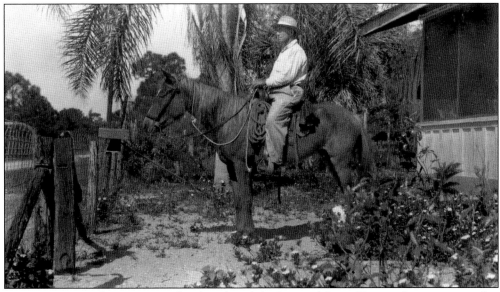

Pioneer James Wallace "J. W." Liles, founder of the Imperial River Tourist Court, sits atop his horse in front of his home on Wilson Street. When he arrived with his four brothers in 1897, Liles initially made a living in agriculture but soon realized the need for travelers to have lodging. In 1927, he built the Liles Hotel on the southern side of the Imperial River.

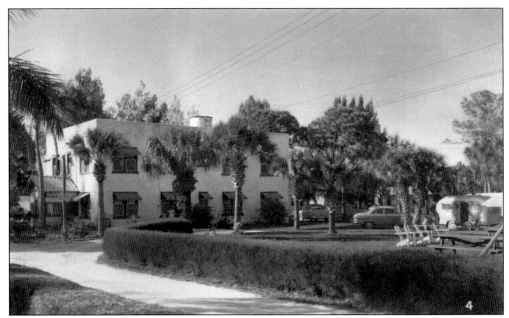

In this postcard of the Liles Hotel and Imperial River Court, one of the many water towers in Bonita Springs can be seen. Behind the hotel is the railroad track, and beyond that is the Heitman Groves. Original owner J. W. Liles had difficulty keeping the hotel during the Depression. Wealthy Naples businessman Ed Crayton purchased it in 1931. The renovated, two-story, masonry hotel still stands today.

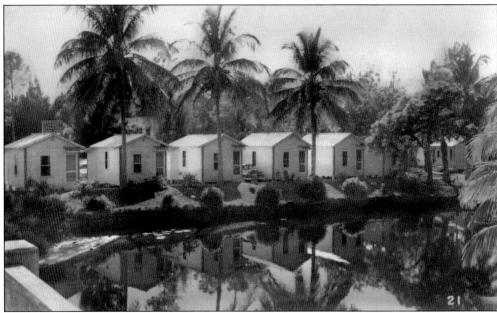

A 1940s postcard features six of the Imperial River Court cottages. Alligators would have been seen occasionally cruising by in the river, and guests would have enjoyed the jungle sounds emanating from the Everglades Wonder Gardens located across the river. The cottages survived numerous floods as well as Hurricane Donna in 1960. The town of Bonita Springs preserved several of them, and today they are used as artist studios.

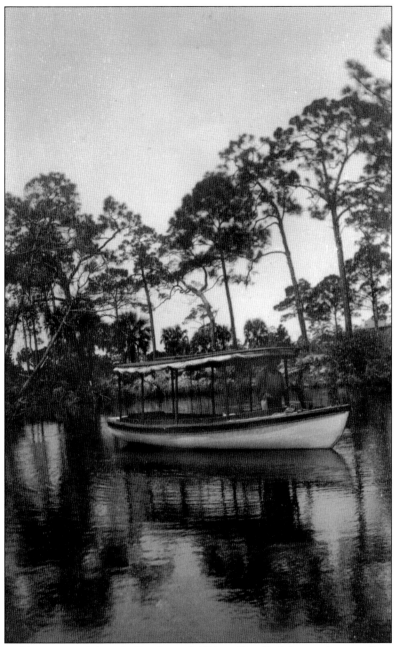

This canopied boat cruised the winding Imperial River. Bundled sheets of canvas line the roof of the boat and are tied back but are ready to be lowered should one of Southwest Florida's frequent rain showers strike. It was a time when the landscape was densely forested with native pine, oak, cypress, and palm trees. Very few houses lined the shore. Clearly, waterfront property was not as desirable then as it is today. Tourists staying at Doc Baird's or the Imperial River Court could catch a river taxi ride and take it all the way out to Bonita Beach. Waterways around Bonita Springs were also often filled with people out in rowboats, especially on a lazy Sunday afternoon. Boaters could witness the frequent jumping of the plentiful mullet fish. At times, the water would literally bubble with great schools of mullet and jack.

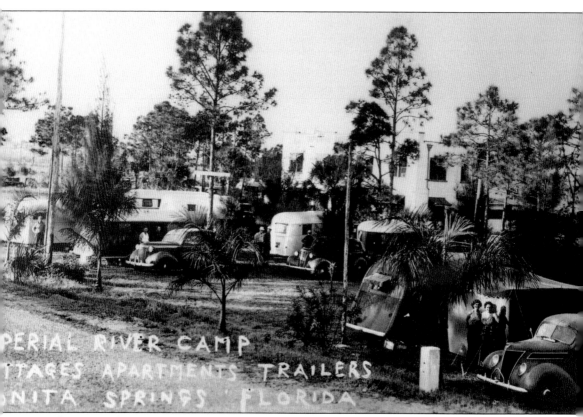

The Imperial River Tourist Court welcomed seasonal visitors year after year from all over the United States. Many arrived in their shiny, metal trailers, which contributed to the nickname "tin-can tourists." The fact that they also came loaded down with canned goods, or tin cans, for their long stays also helped. Originally, many Americans regarded auto camping as a rich man's hobby in these years after the Great Depression. However, well-publicized camping trips to the nation's national parks by prominent citizens Henry Ford, Thomas Edison, naturalist John Burroughs, and Harvey Firestone helped the cause. The men called themselves the Four Vagabonds, and their adventures sparked an increased interest in camping. Camping proved to be an affordable way for many families to vacation, and in the early days, trucks were converted into sleeping campers.

During the 1950s and 1960s, the Imperial River Tourist Court was owned and operated by Ellen and Wendell Gourley. Wendell Gourley is pictured in front of the cottage door in the baseball cap wearing a white tank top. Like many Florida campgrounds and resorts then and now, the resort had a shuffleboard team. Many mobile home parks competed against each other in shuffleboard tournaments.

This page from the Imperial River Tourist Court registration book dates to 1955, when the Gourley family owned the property. Visitors signed in and listed their addresses. They came from as close as Miami and St. Petersburg to as far away as California and Canada. They also included the makes of their cars, which were classics such as Packard, Studebaker, Hudson, and Nash. The highest cabin rate appears to be $14 a night.

83

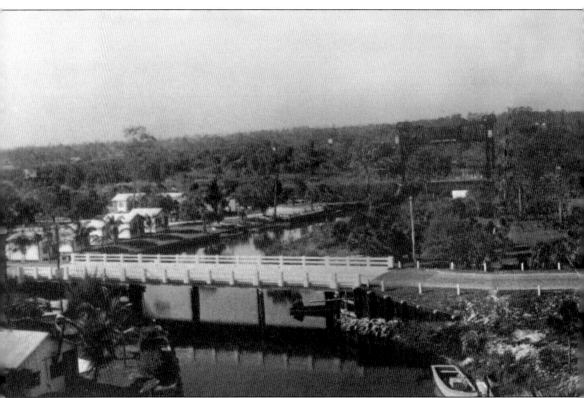

This remarkable photograph shows a panoramic view of Old 41, the Tamiami Trail, in Bonita Springs around 1940. One can see the concrete bridge over the Imperial River. In the foreground is Doc Baird's Camp, and on the other side of the road is the Imperial River Court. The Everglades Wonder Gardens, then still called the Reptile Gardens, can be seen on the right. The railroad

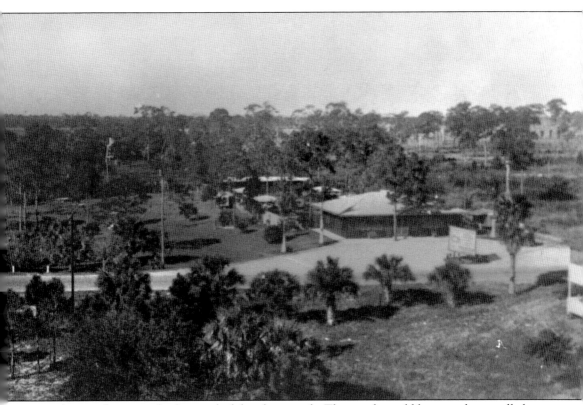

trestle is in the center background of the photograph. The trestle could be moved manually by turning a large crank connected to gears. This would lift the bridge, including the railroad track, to allow boats to pass underneath.

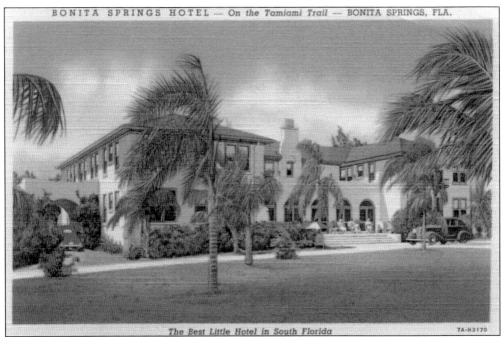

The Shangri-La Resort in Bonita Springs is a well-known landmark, which still stands today. Gilmer Heitman built the original structure in 1924 and called it the Bonita Springs Hotel. The road that ran directly in front of the hotel, Heitman Avenue, was named for Gilmer's brother, Harvie, who owned large tracts of land in town. Today Heitman Avenue is known as Old 41.

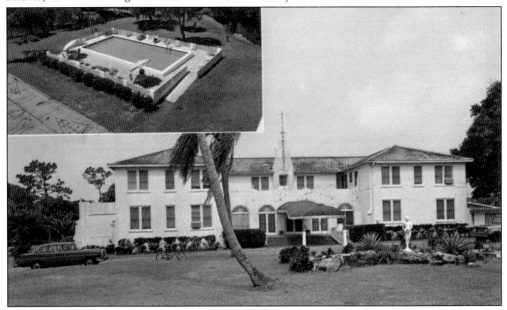

A practitioner of alternative medicine, Dr. Charles Gnau bought the hotel in the 1960s and promoted it as a natural spa. The hotel's next owner, R. J. Cheatham, continued this tradition. He renamed the hotel the Shangri-La and started offering a spa-like menu of healthy dietary offerings, yoga, and meditation. After Cheatham died in the late 1970s, his widow, Frances, ran the hotel until it was sold in the early 1990s.

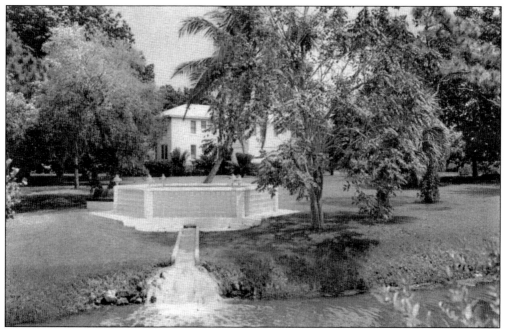

The original spring that Bonita Springs was named for sits on the hotel's eight-acre property. It still flows into Oak Creek and can be seen by looking carefully through the fence from Old 41. The sulfur-laced water bubbling up became part of the signature spa identity that was marketed to guests. Plans to bottle the spring's water did not materialize.

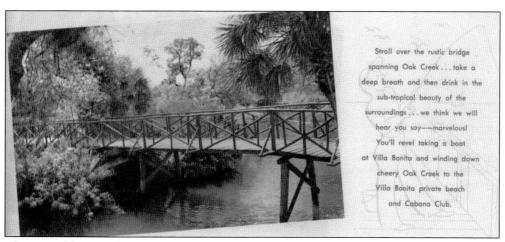

Stroll over the rustic bridge spanning Oak Creek... take a deep breath and then drink in the sub-tropical beauty of the surroundings... we think we will hear you say—marvelous! You'll revel taking a boat at Villa Bonita and winding down cheery Oak Creek to the Villa Bonita private beach and Cabana Club.

The natural beauty of Bonita Springs's environment was one of the strongest selling points for luring visitors to the area. With several creeks flowing into the Imperial River, natural springs, and superb fishing and hunting, it is no wonder the town grew steadily, even during the Great Depression. The Oak Creek bridge, seen in the photograph, on the Shangri-La property certainly enhanced daily nature walks for guests.

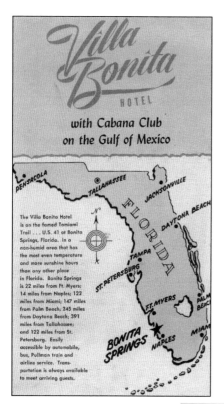

This brochure map, from a period when the Shangri-La was known as the Villa Bonita, depicts Bonita Springs as a tourist destination along with some of the most well-known cities in the state. Locals in Bonita Springs considered the hotel a place for the rich and famous. The Cabana Club beach property was an amenity for guests at the resort and was a unique offering for an inland hotel.

Val Halla Motel was located on the north end of Bonita Beach near Hickory Pass. It was built and operated by George Randolph in the late 1940s. The building in the lower right was lived in by Charlie and Hazel Weeks. The building on the right side channel was the Royal Fish House. It is unclear what happened to the cottages after Hurricane Donna. Val Halla is now a mere memory.

Seven
GATORS AND PANTHERS AND BEARS! OH MY!

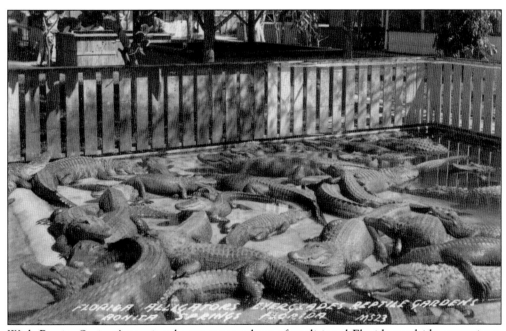

With Bonita Springs's tourism boom came a host of traditional Florida roadside attractions. Chief among them was the Everglades Wonder Gardens. The alligator pit surely impressed and frightened many guests. The pit's most famous resident for many years was a gator named Big Joe. Lester Piper, one of the founders, was once breaking up a fight between two bull crocodiles when he ended up falling into the pen. Fortunately, he escaped with only broken ribs.

This 1936 photograph shows the newly completed Old 41 bridge and the Eagle Hotel. The property in the lower left is owned by brothers Bill and Lester Piper. They spent months clearing it by hand with machetes. In the wooden pens, the Pipers kept snakes they collected on outings into the Everglades. Soon the Pipers would open their attraction featuring Florida reptiles as the Everglades Reptile Gardens, as it was originally known.

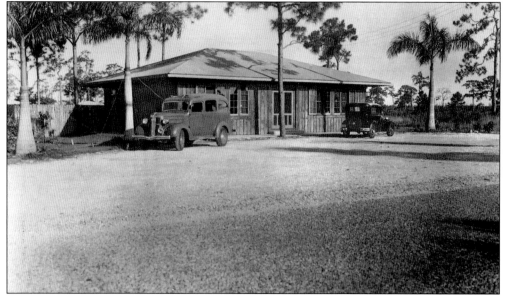

When it first opened in 1936, the entrance to the Everglades Reptile Gardens sat along an unpaved Old 41. It was the beginning of what is now the oldest tourist attraction of its kind in Southwest Florida. Admission was 25¢. The original hardwood pine building would later be raised off the road and a front porch added. Inside there was a small museum of Native American artifacts and souvenirs. The display is still there.

This original sign for the Pipers' Everglades Reptile Gardens was located in front of the main entrance along Old 41. However, travelers would start seeing signs for the attractions as far back as the Georgia state line. Standing in front of this sign are (from left to right) gift shop worker Helen Hayes Galloway, Armond Humphries, and Mary Laura Galloway Lyles.

Lester (left) and Bill Piper (right) talk with guests visiting the Everglades Reptile Gardens. It was Lester's idea to develop a wildlife exhibition on their riverfront land in Bonita Springs. They discovered that the word *Everglades* drew patrons, while use of the word *reptile* caused many motorists, especially those with squeamish passengers, to pass on by. To draw more customers, the business became known as the Everglades Wonder Gardens by the end of the 1940s.

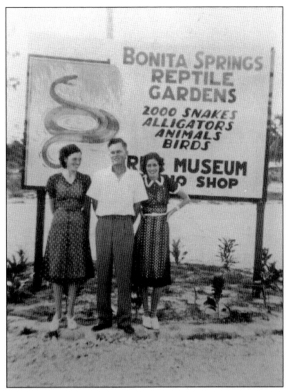

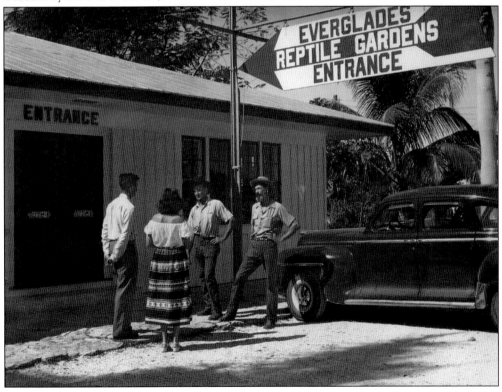

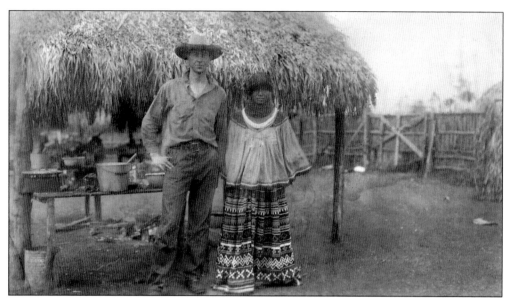

The Piper brothers established a relationship with Florida's Seminole people through a common respect for the land and the Florida wildlife. Bill, pictured with a Seminole woman, was asked to attend the Seminole Conference of 1936. He was known as a "friend of the Indian." The Seminoles sometimes brought animals to the brothers as well as goods and handmade items to sell in the gift shop.

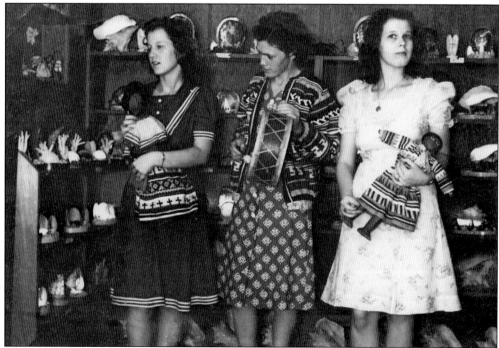

Local ladies Geraldine Strickland (left), Helen Hayes (center), and Blanche Humphries (right) visit the Everglades Wonder Gardens gift shop. Helen is wearing an authentic Seminole jacket, and the other girls hold traditional Seminole dolls made of palmetto fiber husk and stuffed with cotton. Other items for sale usually included local shell craft, as seen lining the walls.

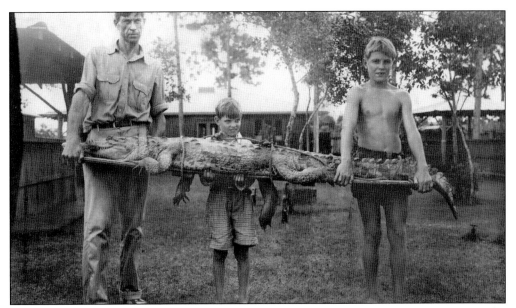

Bill Piper enlisted these two local young men to help him with a crocodile. Donald Trew is in the middle and his older brother, Alfred, is on the right. At one time, the gardens had a crocodile enclosure with about 30 adults. During the 1950s, the Piper's crocodile collection was the largest in Florida. Crocodiles can live in saltwater, have a more narrow snout than alligators, and have teeth that jut out.

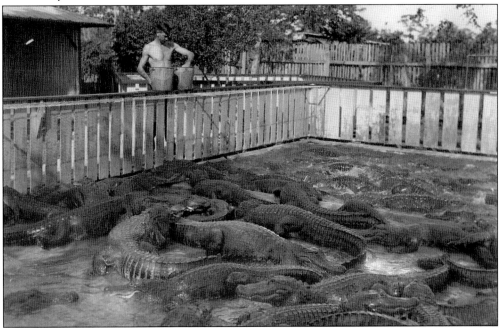

In 1958, Immokalee Road was the site of an alligator hunt. Lester's son, David Piper Sr., drove his jeep along the roadbed at night wearing battery-powered headlamps. With him were other Everglades Wonder Gardens guides. Finding the reflection from a gator's eyes, they captured it and took it back to the attraction. During another hunt, Bill Piper lost a portion of his thumb to an alligator, which ended his guitar playing.

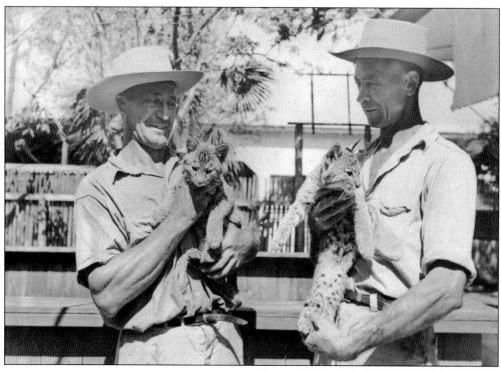

Lester (left) and Bill Piper (right) hold two panther cubs at the Everglades Wonder Gardens. By 1945, the brothers' roles began to diverge. Lester spent seven days a week tending to the animals and gardens he loved, and Bill became more interested in cattle ranching and other projects. Near the end of their lives, the brothers divided their assets. In 1981, Lester became sole proprietor of the Everglades Wonder Gardens.

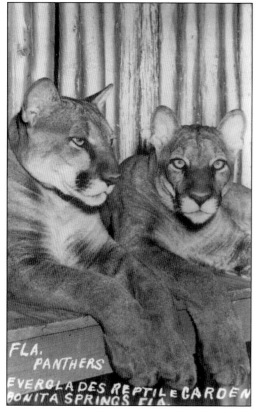

Two of Lester's male panthers were born to a female named Queen at the Everglades Wonder Gardens. Her offspring, pictured here in the 1950s, were used in a breeding program. Breeding in captivity is difficult because when a new mother becomes anxious, she may kill her kittens. The Pipers experienced this and began watching closely for warning signs and removing cubs early. They successfully raised 18 panther cubs.

Bill (below) and Lester Piper did not shy away from the poisonous snakes at the gardens. Many outings into the Everglades yielded new specimens. In the 1940s, Florida governor Millard Caldwell responded to complaints of snake shows that were fronts for gambling rings. In an open letter to local sheriffs, Caldwell stated, "This is giving our state a bad reputation, therefore you are requested to examine any such operations and take such steps necessary to arrest the operators." When the Piper brothers got wind of this allegation, they responded with a letter to Caldwell that was published in the local newspaper. It defended their "reputable enterprise" and cited examples of racketeers posing as wildlife officers and of bribing local officials to allow gambling in their counties. In addition to educating the public about snakes, the brothers were known to send pharmaceutical companies venom samples for testing.

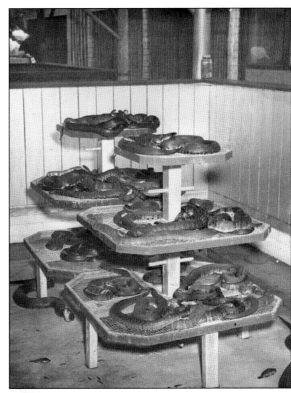

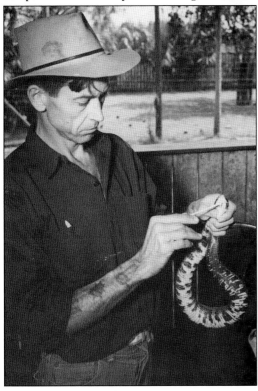

Bill Piper's program of raising bears started in 1941 while on an outing in Collier County, where he found three Florida black bear cubs floating on a log. Bill carried them home in a gunnysack. They were named Tom, Dick, and Harry until it was discovered that Harry was actually Harriet. In the years that followed, the Piper brothers succeeded in raising 20 bear cubs in captivity.

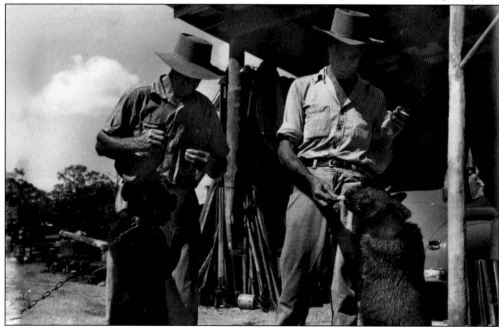

The Piper brothers' interesting history started long before the Everglades Wonder Gardens. Bill (right) was born in 1900 and Lester (left) in 1902 in Lancaster, Ohio. After serving in the military and a brief run as bootleggers in Detroit, Michigan, the brothers moved to Florida and purchased the property along the Imperial River that would become the Gardens. Lester's grandson, David Piper Jr., is the current owner of Everglades Wonder Gardens.

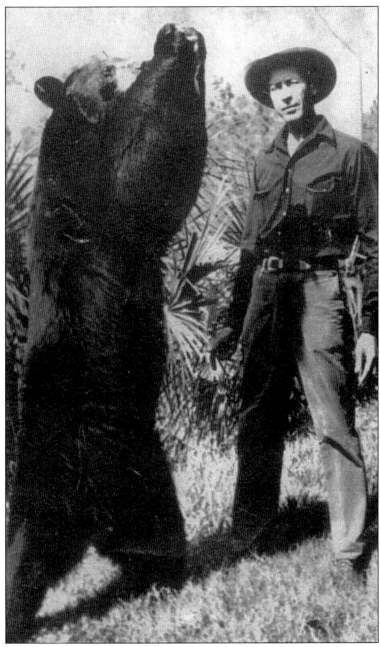

Bill Piper's bear Tom, also known as "Old Slewfoot," made his acting debut in the 1946 feature film *The Yearling*. The famous bear, seen here in a publicity photograph along with Bill, brought thousands of visitors to the tourist attraction to see him. Bill Piper worked closely with Tom, whose favorite beverage was Pepsi-Cola. Despite the staged photographs, Tom was not completely tame. In one instance, when Bill took his soda away before he was finished, the enraged bear attacked Bill, biting and clawing him. When Bill fell to the ground, the bear walked back to his cage. He needed 27 stitches to repair wounds to his throat and shoulders. Florida black bears stand 5 to 6 feet tall and can weigh between 250 and 450 pounds. Bill Piper always respected the strength of his omnivorous friend. Tom died of natural causes relating to old age in 1957.

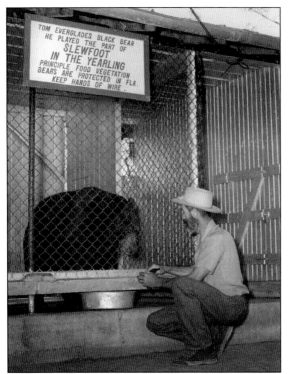

While filming a scene in *The Yearling*, Bill Piper was running through the Ocala National Forest being chased by Tom. As he looked over his shoulder, Bill fell in a puddle. Thinking Tom would stop and grab him, he was surprised when instead the bear stepped on him and kept running. The crew members were so caught up in the moment, they forgot to capture the scene on film.

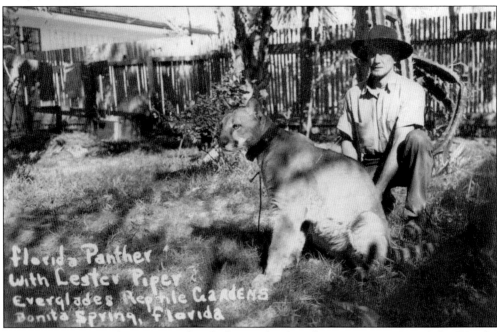

Lester Piper is most often associated with the panther breeding program at Everglades Wonder Gardens. The cubs that were brought there or born there were hand-raised by Lester and his wife, Lucille. At times, the breeding program of the endangered Florida Panther came under scrutiny, but reports have shown that Lester's cats were genetically pure. He is responsible for at least seven releases of cats born in captivity into the Everglades National Park during the mid-1950s.

Bill Piper received this signed photograph from a member of the crew after the completion of filming for *The Yearling*. He was asked several times to allow filming on his land in Lee and Collier Counties, as well as to loan animals for projects. He was a friend of Marlon Perkins of *Wild Kingdom* fame as well.

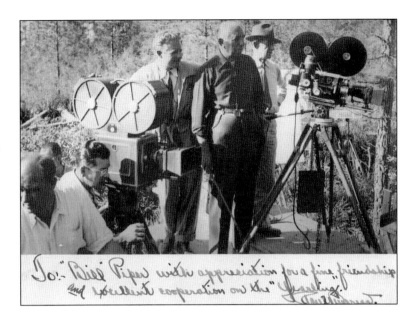

One of the other films Bill Piper was involved with was *Distant Drums*, starring Gary Cooper. Because Bill had a similar build, he doubled for Cooper in shots like the one pictured here, which required him to interact with the environment. The 1951 Western took place in 1840s Florida when Cooper, playing an army captain, leads a raid on a Seminole fort and then retreats into the Everglades.

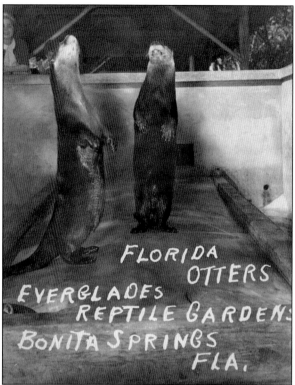

River otters have long provided a charming display at the Everglades Wonder Gardens. The animals are easily trained and are naturally active. They like to chase, wrestle, swim, and slide in their habitat. They can live up to 25 years in captivity. Loss of natural habitat and pollution are the greatest threats to their survival.

Bill Piper was asked to lend his expertise during the creation of the National Audubon Society's Cypress Swamp Sanctuary in 1954. He and the crew spent a long time tramping through the swamp using buggies. Bill was determined to help save the cypress forest from loggers. Outings for Bill were occasions to rescue and collect reptiles or birds. He was bit several times by rattlesnakes but never killed one himself.

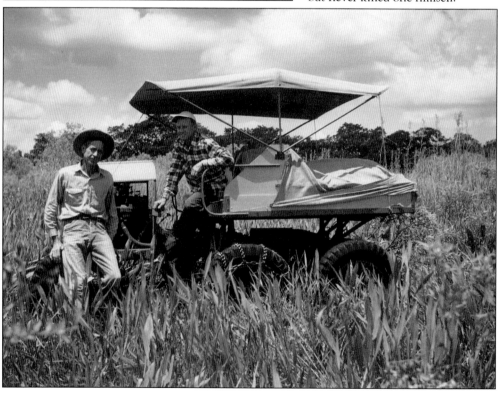

Eight
REMEMBER THE DOME

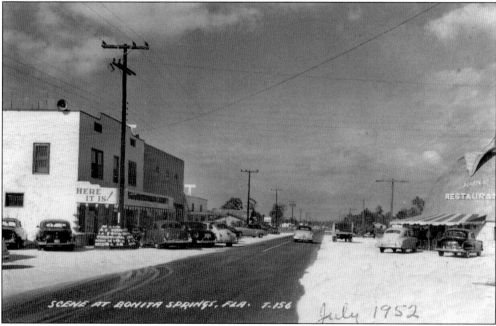

There were plenty of other popular tourist attractions in Bonita Springs. This wonderful photograph from 1952 captures two beloved sites in their heyday. On the left sits the original Shell Factory, a famous store and factory that sold a huge variety of shell-related products. On the right is the Dome Restaurant, an orange-roofed diner topped by a green leaf that was a Bonita Springs landmark for decades.

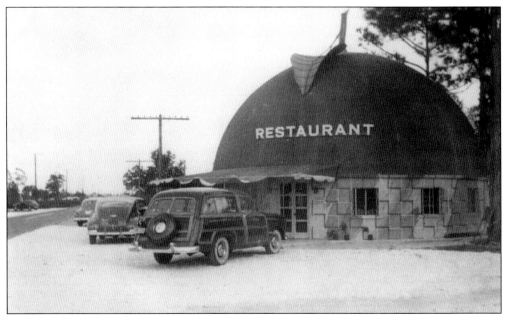

The Dome Restaurant was one of the most famous landmarks in Bonita Springs. Built in the early 1940s as a rest stop for thirsty travelers, tourists could sample fresh-squeezed orange juice. The bottom portion was constructed using ammunition boxes left over from the Buckingham gunnery school near Fort Myers, where World War II airmen trained. Covered with coral rock, the structure was capped with a bright orange domed roof and topped by a green leaf. The Dome was badly damaged during Hurricane Donna in 1960 but was repaired. The Dome eventually became more of a local watering hole than a tourist stop. Long located at the intersection of Terry Street and Old 41, it was torn down in 1992 to make room for road improvements. Plans to save the structure were proposed but never happened.

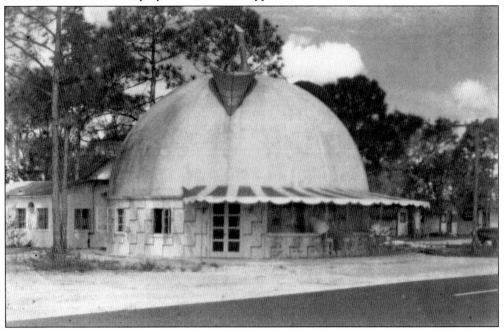

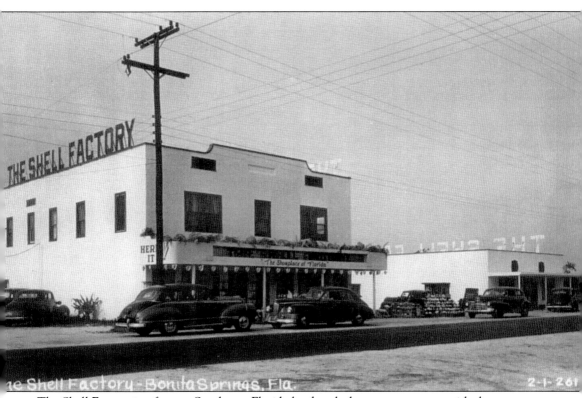

The Shell Factory is a famous Southwest Florida landmark that many connect with the current roadside attraction along U.S. 41 in North Fort Myers. The Shell Factory, however, has its roots 30 or so miles to the south in the community of Bonita Springs. That is where the original Shell Factory once stood proudly in the downtown area. Shells of all shapes and sizes were sold there, and souvenirs made with shells were created and shipped around the world. Despite the wonderful beaches nearby, many of the shells sold at the Shell Factory were not local. Indeed, rare shells from the Caribbean, South America, the South Pacific, Mediterranean, and other areas were imported to the Shell Factory. The shelves were lined with exotic-looking shells, which likely included favorites such as queen conchs, cowries, spider shells, Australian trumpets, and fox shells.

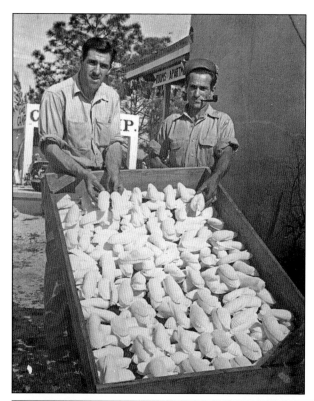

Harold Crant and his wife, Mildred, opened the original Shell Factory. The couple, initially from Nova Scotia, fell in love with Bonita Springs during a 1938 winter vacation here. Harold (left), pictured here with Artie Futch, purchased a small building on the north end of the village and began selling shells to tourists.

With 50 employees, the Shell Factory soon became one of the largest businesses in Bonita Springs. Many others in the community who made or sold supplies for the factory also depended on it for their livelihoods. The Shell Factory soon became a major stop for tourists traveling on the Tamiami Trail.

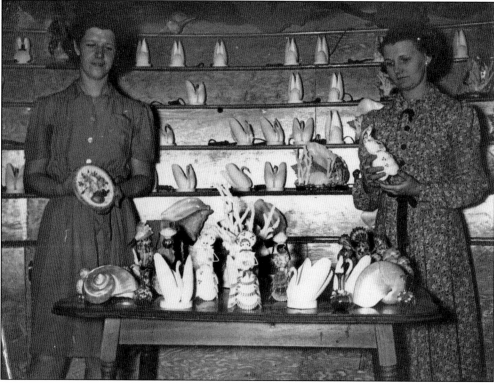

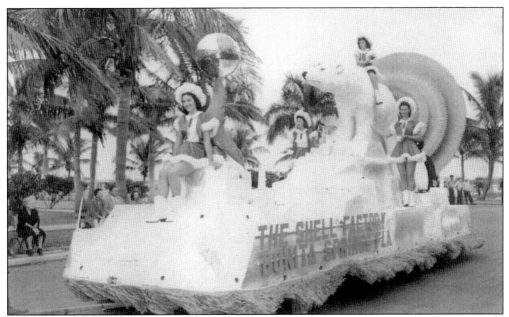

The Edison Festival of Light Grand Parade, a yearly event since 1938, brings crowds of people to downtown Fort Myers. The Shell Factory in Bonita Springs joined the procession of floats and bands with this curious entry in which the theme was a winter scene. It featured a seal, some penguins, and a polar bear but nary a shell in sight. (Image courtesy WGCU Public Media.)

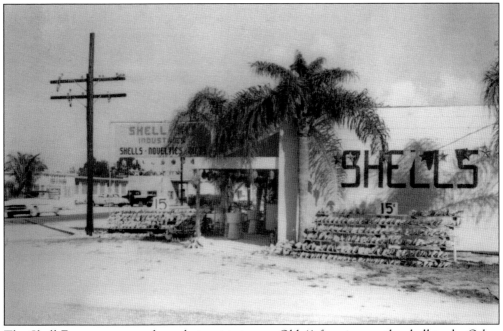

The Shell Factory was not the only tourist stop on Old 41 focusing on the shell trade. Other small shops and stands opened along the trail, enticing the thousands of northerners who passed by each year on their way to and from Naples and Miami. When viewed closely, beautiful conch shells selling for 15¢ can be seen in this photograph.

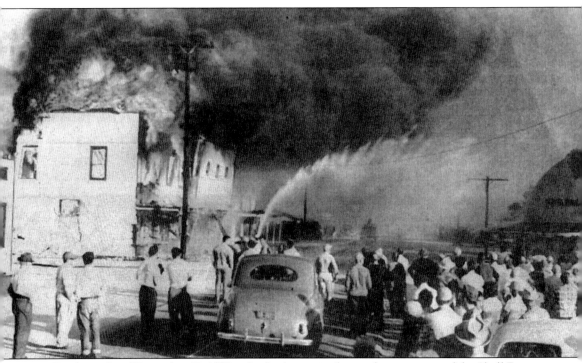

On the night of December 31, 1952, a fire broke out in the southwest corner of the Shell Factory building. Flames crept up the dry walls, through showrooms, and across the factory floor. The sprinkler system in the building failed to work, and strong winds that New Year's Eve quickly swept the blaze through the enormous structure. Firefighters from Fort Myers sped to the scene but arrived too late. The Shell Factory was destroyed. The town was stunned. The loss of the attraction was a major blow to Bonita's economy. It was the biggest single employer in the community, and dozens lost their jobs. The loss was compounded when Harold Crant chose to rebuild the Shell Factory in a new location—on the Tamiami Trail in North Fort Myers. It still stands there today and remains one of the most well-known tourist attractions in Lee County. (Image courtesy WGCU Public Media.)

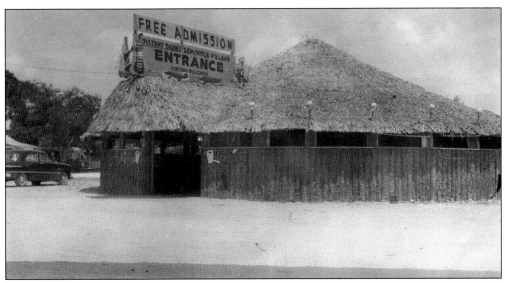

The Distant Drums Seminole Village was opened by Shell Factory owner Harold Crant on the southeast corner of Terry Street and Old 41. He created a working village, meaning the Seminole Indians he employed actually lived at the attraction. The Native American residents would make and sell souvenirs to visiting tourists. There was also a pit where alligator-wrestling shows were held.

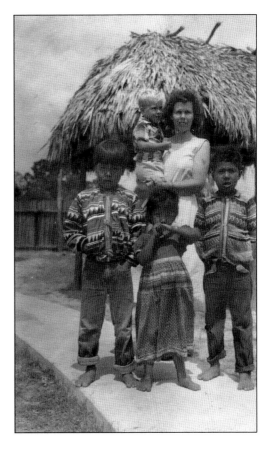

Robert Daughtry, a longtime Bonita resident, remembers when he befriended a few Seminole boys at Distant Drums. They showed their new friend how to cook and enjoy gar, a needle-nosed fish not commonly considered edible. When the Shell Factory burned, the Seminoles at Distant Drums feared the tourist trade in Bonita would dry up, and they left for parts unknown. This photograph shows lifelong Bonita resident Blanche Liles and her son, Alan, with Seminoles from Distant Drums.

Believe it or not, Bonita Springs had a house of illusion in the late 1950s called the Mystery House. Located near other popular attractions, locals recall that the Mystery House claimed to be a locale where gravity did not work correctly. Visitors of the Mystery House might have felt light-headed as the oddly angled rooms threw off their balance. Demonstrations seemed to show water flowing uphill or a person leaning off a step at a steep angle without falling. In reality, the Mystery House was not unique. In the mid-20th century, many similar gravity-defying attractions were sprinkled around the United States. A well-known one in Santa Cruz, California, still goes by the name Mystery Spot, while one in Lake Delton, Wisconsin, was called the Wonder Spot. Edith Downs, the owner of Bonita's Mystery House, actually lived in the wacky home. (Image courtesy WGCU Public Media.)

The Naples–Fort Myers Greyhound Track officially opened on the evening of December 27, 1957. Newspaper advertisements on the track's opening day read, "Be there when the cry goes up—Here comes the bunny!" It was big news around Southwest Florida, and an estimated 1,589 people poured into the new facility for the first race at 8:00 p.m. The crowd was so large the parking lot filled up quickly, and cars were lined up along Old 41. Many local dignitaries attended, including Lee County sheriff Flanders "Snag" Thompson, Mayor Roy Smith of Naples, and others. The local newspaper was filled with reports and photographs of the exciting evening and, for years afterwards, would publish race results in the sports section. That first night saw $26,262 in betting. Despite being located in Bonita Springs, the owners chose to name the track after the larger, better known towns located to Bonita's south and north. This might have helped with marketing and name recognition, but it is a fact that has stuck in the craw of many Bonita Springs residents ever since.

Over the years, a diverse menagerie of celebrities spent evenings at the track, including comedian Buddy Hackett, golfer Fuzzy Zoeller, Chicago Bears coach Mike Ditka, and Charles Edison, son of the famed inventor. Many baseball stars, particularly those from teams that held spring training in Southwest Florida, were also guests at the track. Pete Rose, Roger Clemens, Kirby Puckett, and Don Zimmer are all on this illustrious list.

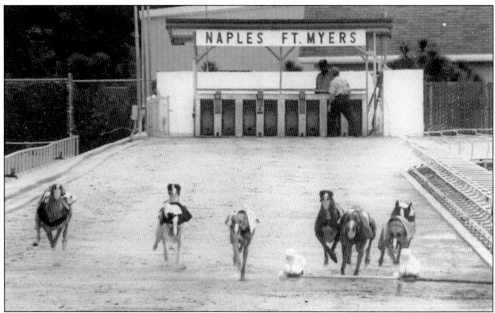

Today the Naples–Fort Myers Greyhound track has had to adapt their business model. As interest in dog racing has dwindled, the track has added off-track betting and poker tables to lure in new visitors. Nonetheless, races are still run most days of the week. The original cry, "Here comes the bunny," was soon replaced by the now legendary "Here comes Sparky," which is still shouted out at the start of every race.

Nine
DONNA'S FURY

Hurricane Donna formed on August 29, 1960, in the cradle of many Atlantic hurricanes off the African coast near the Cape Verde Islands. Heavy rains and thunderstorms were reported at first, and the storm quickly grew and strengthened for the next week as it traveled across the warm ocean waters. When it hit the Leeward Islands, winds were clocked at 125 miles per hour. Widespread damage was reported across the Caribbean. (Image courtesy NOAA.)

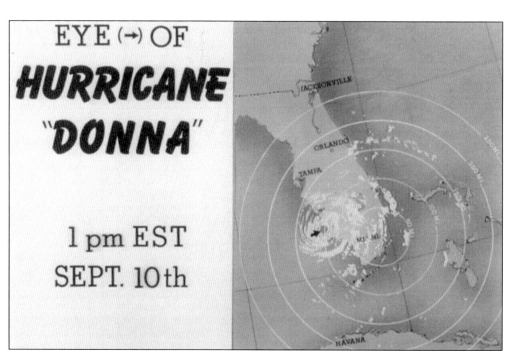

Media began to call the storm a killer hurricane, which had now turned toward the Florida Keys. Weather bulletins characterized Donna as a "hydrogen bomb exploding every eight minutes." Residents of the Keys fled north to the mainland. In the early evening of September 9, 1960, winds arrived and strengthened throughout the night. Gusts howled at 150 miles per hour, and a 13-foot-high storm surge pounded the islands. (Image courtesy NOAA.)

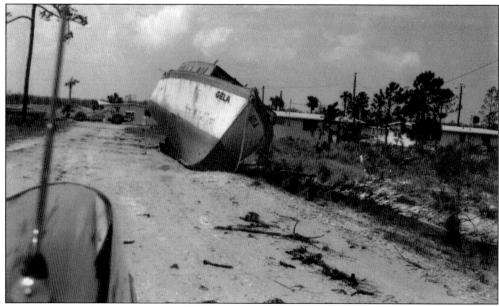

As Donna curved toward a northern track, it came ashore on the morning of September 10, 1960, along the coast of Naples and Fort Myers with an eye 21 miles wide. Bonita Springs was right in the storm's path. Donna exited back into the Atlantic Ocean near Ormond Beach, Florida. This image shows R. Sheffield's boat, which was carried by strong winds across a local road.

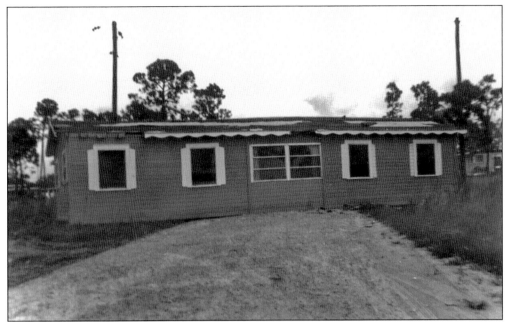

The National Weather Service estimated that Naples saw sustained winds of 100 miles per hour with gusts up to the 140 to 150 range. By the time Donna reached Fort Myers, sustained winds were clocked at 92 miles per hour with gusts up to 121 miles per hour. Bonita Springs lies directly between Naples and Fort Myers. This Simmons Apartment building was carried more than a mile from its original location and left across a road.

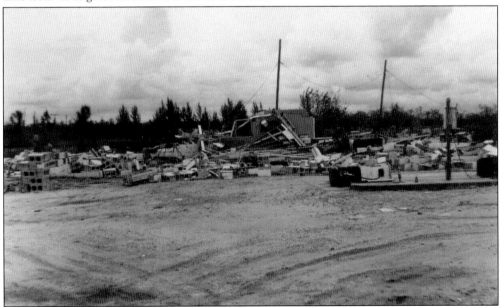

The inland community of Bonita Springs suffered extensive damage, while many homes and businesses closer to the beach were destroyed outright. According to newspaper reports, the storm pushed an 11-foot-high tidal surge onto the shores of Bonita Beach, smashing everything in its path. Other area communities such as Naples and Fort Myers Beach were also devastated. Reports say more than 12,000 truck loads of tree limbs were hauled away in Fort Myers.

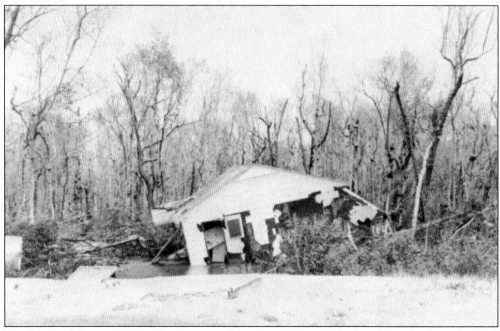

The home of Cass and Polly North originally sat on pilings on the beach overlooking the Gulf of Mexico. After the storm, their house had been blown off its timber perch into the mangrove trees across Hickory Boulevard. Sheriff deputies, national guardsmen, and local volunteers set up barricades and blocked local roads to keep looters from gaining access to storm-ravaged homes and buildings.

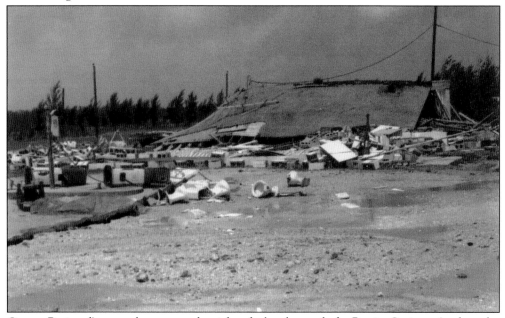

George Brainerd's general store was the sight of a local tragedy for Bonita Springs. As the calm eye of Hurricane Donna passed over the community, Brainerd, 54, returned to his business to check on it. He never made it back home. His body was found two days after the storm more than a mile away from his demolished store.

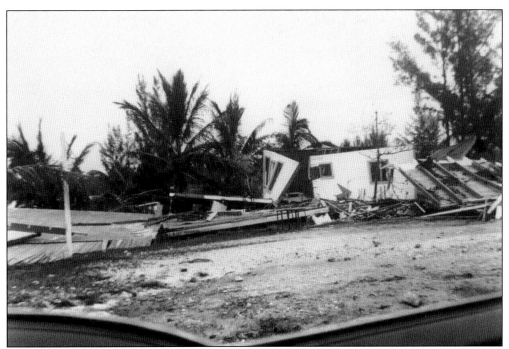

A. A. Lindeau, better known around town as "Lindy," chose to stay and ride out the storm in his trailer next to the lunch stand he operated. The 75-year-old man's property was destroyed by fierce winds, and his body was found three days later.

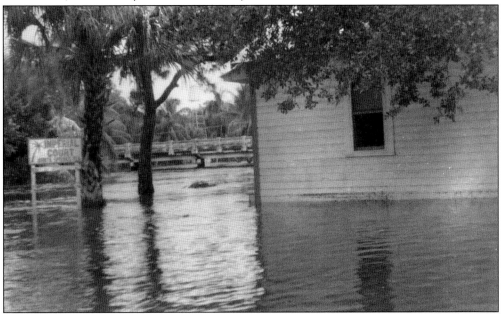

Tides along the Lee County coast were estimated to be anywhere from 4 to 7 feet above normal. Many streets, neighborhoods, homes, and businesses were flooded. The potential for flooding from Donna was increased by heavy rains during the three weeks previous to the storm's arrival. Lakes and streams overflowed in some areas and forced residents to evacuate their homes. High waters also closed many roads and inundated farm fields across the storm's path.

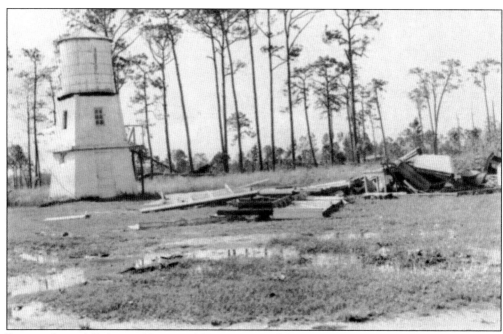

Reported rainfall during Hurricane Donna ranged from 5 to 10 inches. The heaviest rains apparently fell on the extreme southern Florida peninsula, with totals near 12 inches in some areas near Miami. Rainfall data for stations south of Fort Myers, including Bonita Springs, were apparently lost when gages were either blown away or tipped over. The debris next to the water tower in the photograph is a destroyed fruit stand.

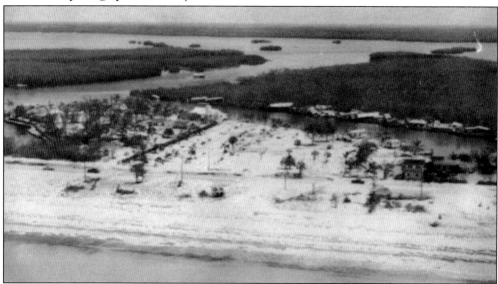

According to author Jay Barnes, wildlife became a big problem in the weeks after the storm. Numerous snakebites were reported, which were mostly from snakes displaced from their waterlogged habitats. Rats were also a health concern. State officials implemented a rodent control program. Five-thousand pieces of poisoned meat were dropped across southern Florida by boat and helicopter in an effort to eradicate the rats. Ultimately, there were no reports of communicable diseases following Hurricane Donna.

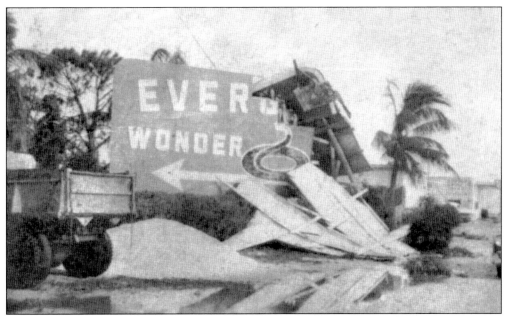

The sign in front of the Everglades Wonder Garden was badly damaged in the storm. So too was an attractive solar screen wall that workers had just finished building before Donna hit. Locals remember fearing that wild animals at the attraction would escape and roam Bonita's streets, but fortunately, this did not happen. Other businesses along Old 41 lost windows, roofing, signs, fences, and trees.

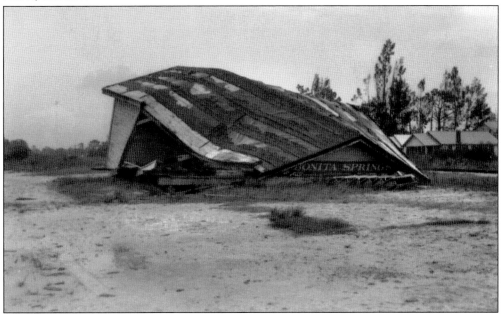

Hurricane Donna destroyed the Bonita Springs railroad depot where area produce was shipped to points north. The storm heavily damaged the agricultural industry around Southwest Florida. Trees were uprooted and branches stripped of leaves and fruit. At the time, the U.S. Department of Agriculture estimated that up to 35 percent of the state's grapefruit crop was lost in addition to about 10 percent of the state's orange and tangerine crops.

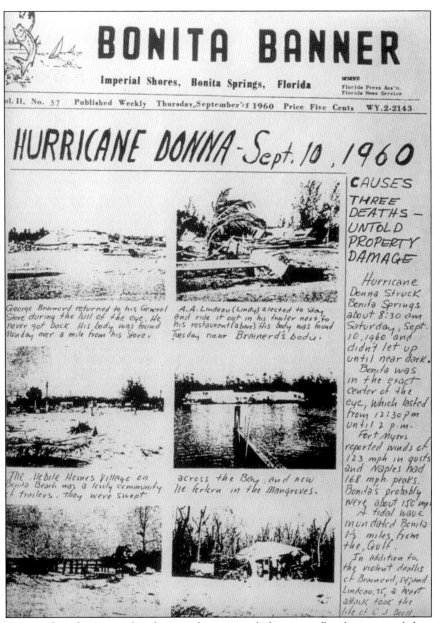

In the hours after the storm, local journalists struggled against floodwaters and damage to report the news. The offices of the *Bonita Banner* were destroyed, as was the publisher's home next door. Nonetheless, the intrepid *Bonita Banner* staff, working from an efficiency apartment behind Bibbee's Market, met their deadline and produced a handwritten version of the weekly newspaper. Filled with photographs and stories of Donna's wrath, the staff wrote, "We are bloody but unbowed." According to the National Oceanic and Atmospheric Agency, Donna was the "deadliest, costliest, and most intense U.S. hurricane of the century" to that date. Including the deaths in the Caribbean, Donna killed more than 320 people, and the damage estimates for Florida approached $300 million. Three deaths were reported in the Bonita Springs community: George Brainerd, 54; A. A. Lindeau, 75; and C. J. Doell, 70, who died of a heart attack while cleaning up in the hours after the storm.

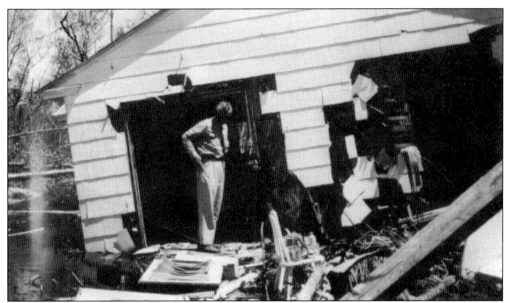

Florida governor LeRoy Collins came to Southwest Florida to view the damage left by the storm. Here he visits a destroyed home near Bonita Beach. In the days after the storm hit, U.S. president Dwight D. Eisenhower declared the area covering the Keys on up to Central Florida a disaster area.

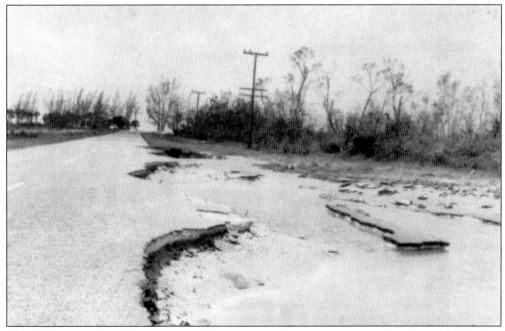

Sheriff Flanders "Snag" Thompson told reporters at the time that Bonita Beach was the hardest hit community in Lee County. The bridge leading to Little Hickory Island and the beach were open only to local residents for some time. Reports say it was "wobbly," and officials feared that the storm had undermined the pilings supporting the bridge and wanted to limit traffic.

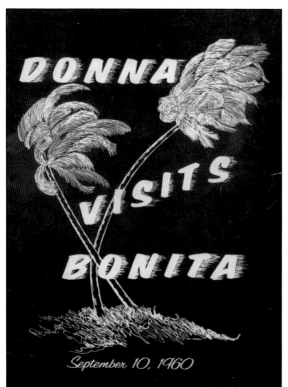

Many of the photographs in this chapter come from the invaluable souvenir booklet titled *Donna Visits Bonita*. It was published soon after the storm by Kiddyland Portraits, a photography studio in Bonita Springs. It documented the extensive damage in the village of Bonita Springs and surrounding communities.

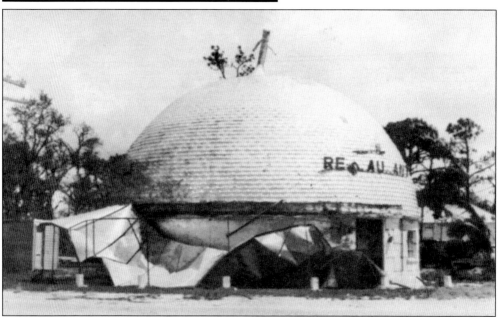

Hurricane Donna heavily damaged the Dome Restaurant, but the owners rebuilt it, and it survived another 30 years before a demolition crew did what Donna could not. Hurricane Donna was the most severe storm to hit Florida for 32 years until Hurricane Andrew tore across the greater Miami-Dade region in 1992. In deference to the terrible destruction and lives lost, the name Donna was retired from the list of hurricane names, never to be used again.

Ten
From Humble Beginnings to Boomtown

In the aftermath of Hurricane Donna, insurance money flooded the area, and with it came many workers who set about rebuilding the community. At the same time, several developments made Southwest Florida a more attractive place to live, including the rise of air-conditioning use and the increase in mosquito control. By the 1970s, Bonita was experiencing another boom. This photograph shows the First National Bank, the first bank in Bonita Springs, which opened in 1963.

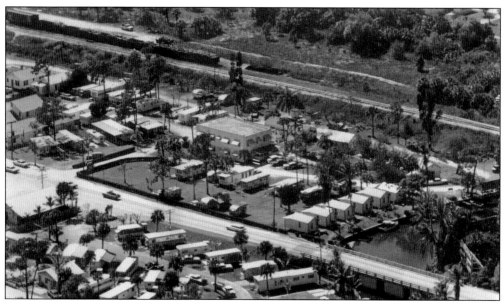

This aerial photograph shows the Imperial River Tourist Court along Old 41 a few years after Hurricane Donna. Citrus groves can be seen at the top of the image beyond the railroad cars. Below Old 41 is the Bamboo Mobile Home Village, and to the left is Doc Baird's. The town had recovered well from the disastrous Donna.

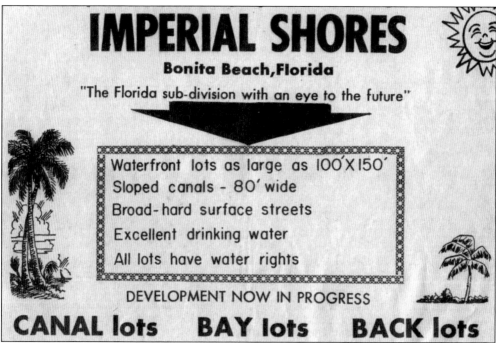

This 1960s advertisement promotes a new development called Imperial Shores. The official plat map filed in April 1960 predates Hurricane Donna by months. The new subdivision, owned by members of the Reahard family, offered non-waterfront lots from $995, canal lots from $2,495, bay lots from $3,995, and river lots from $5,995. With $100 down and $100 a month, a buyer could finance gulf-access property.

In the early 20th century, much of the Bonita Springs area was considered somewhat unlivable by many. Coastal marshes were thick with mosquitoes and were primarily the domain of fishermen and hunters. This all started to change in the 1950s as mosquito control districts began spraying pesticides in certain areas of the county. In 1958, the formation of the Lee County Mosquito Control District brought these efforts under one roof. The agency used airplanes to spray many areas, and in 1961, Lee County Mosquito Control District got their first DC-3, which soon became a common site in the skies around the county. In 1977, the first Huey helicopters took to the skies, which are still a familiar site today. The development of effective mosquito control methods opened the door to more and more families finding southern Lee County an acceptable place to live. (Image courtesy Lee County Mosquito Control District.)

In 1967, the Lawhons, longtime grocery market operators, opened a new modern store called Lawhon's Suprex on Bonita Beach Road. The first of its kind in Bonita Springs, it debuted to much fanfare with a big ribbon-cutting ceremony. By 1973, the Lawhons had built a bigger supermarket across the street. Pictured here, it was part of what was known as the first strip mall in the community. Robert Lawhon Jr. joined his father as manager. It closed in the 1980s.

During the 1980s, the Liles Hotel became apartments for rent. The hotel was temporarily named "Royal River Court" when a Hollywood film crew paid a visit to Bonita Springs. During the filming of *Just Cause*, starring Sean Connery, the hotel served as a backdrop. Set crews painted the palm tree and a new hotel name. In 2003, the newly formed City of Bonita Springs purchased the hotel and property.

Bonita Springs continues a tradition of celebrating its resources even today. During the 1970s, the Tomato Snook Festival, Tomato Mullet Festival, and Tomato Seafood Festival took place. It was the same festival each year; the only thing that changed was the name. Today the "Celebrate Bonita" festival takes place in April, marking the city's second incorporation on December 31, 1999, after an earlier stab at it some 80 years before.

As Bonita Springs grew, so did the Hispanic population. At first, many were seasonal workers who came to work in the tomato fields or in other agricultural jobs. Over time, many of these migrant workers settled here full time. The Hispanic population in Bonita is now nearly 20 percent of the city's residents. Their presence has changed the face of Old 41 in Bonita with many Mexican restaurants and businesses catering to a Hispanic clientele.

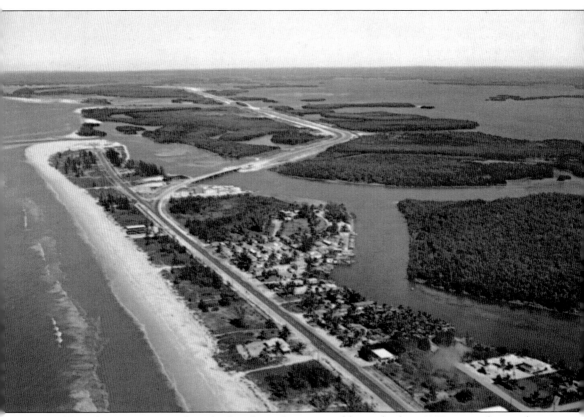

Although a primitive trail to the beach made it accessible in the late 1920s, growth was slow. The peninsula that is Bonita Beach, pictured in this 1960s aerial photograph, shows few homes and no condominiums. Bridges over the passes connected Bonita Beach to Estero Island and Fort Myers Beach. A small mobile home community on the Back Bay can be seen in the center. The building boom reached Bonita Beach during the 1970s. Today a walk down this same stretch of sand would be dominated by packed-in beachfront homes that crowd the shoreline. While some of these homes are smaller, old-fashioned beach bungalows, more and more are becoming modern two- and three-story mansions. Prices start at several million dollars and go up from there. Condominium towers have also popped up. While the look of Bonita Beach might have changed, the same sand and sea greet visitors just as they did 100 years ago.

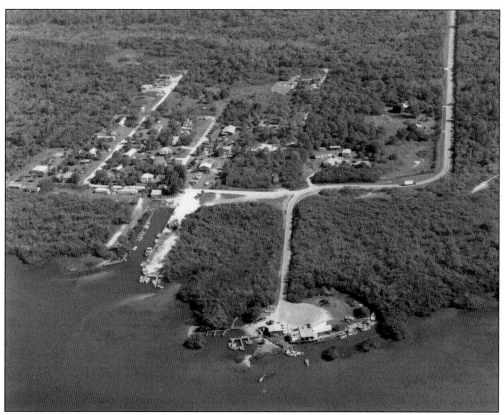

This area at the end of Coconut Road has dramatically changed in the years since this aerial photograph was taken in 1984. Two prominent fishing families, the Weeks and the Johnsons, made their homes along the bay in the image. Weeks Fish Camp, on the left, included many family homes, a bait shop, and a boat ramp. It continued to prosper despite enormous damage from Hurricane Donna. For years, Charlie Weeks offered boat tours to Mound Key. The Johnson family operated the fish-processing center on the right. Perhaps the biggest blow to this lifestyle came with the net ban of 1995, which put an end to generations of net fishing in the Gulf of Mexico. Today Coconut Road has been straightened and runs west all the way to the bay. It ends at the luxurious Hyatt Regency Hotel at Coconut Point. The sale of the properties and hotel construction marked an end to one of the longest-enduring traditions in Bonita Springs but also marked a new beginning in the next chapter of this vibrant and ever-changing Florida community.

ABOUT THE ORGANIZATION

The Bonita Springs Historical Society was founded in September 1984 with the goal of studying, preserving, and promoting the history of Bonita Springs. Over the years, the society has developed multimedia presentations on the community's birth and growth; set up a speakers lecture series; produced maps, brochures, and videos highlighting the area's development; and tape-recorded oral histories of early pioneers. Members have also created an irreplaceable resource and archive library filled with history books and family photographs from the community's early days. With offices in the landmark Liles Hotel, the Bonita Springs Historical Society members invite you to join them in their efforts to preserve this unique community's important legacy.

Discover Thousands of Local History Books
Featuring Millions of Vintage Images

Arcadia Publishing, the leading local history publisher in the United States, is committed to making history accessible and meaningful through publishing books that celebrate and preserve the heritage of America's people and places.

Find more books like this at
www.arcadiapublishing.com

Search for your hometown history, your old stomping grounds, and even your favorite sports team.

Consistent with our mission to preserve history on a local level, this book was printed in South Carolina on American-made paper and manufactured entirely in the United States. Products carrying the accredited Forest Stewardship Council (FSC) label are printed on 100 percent FSC-certified paper.